the Museum of Broken Relationships

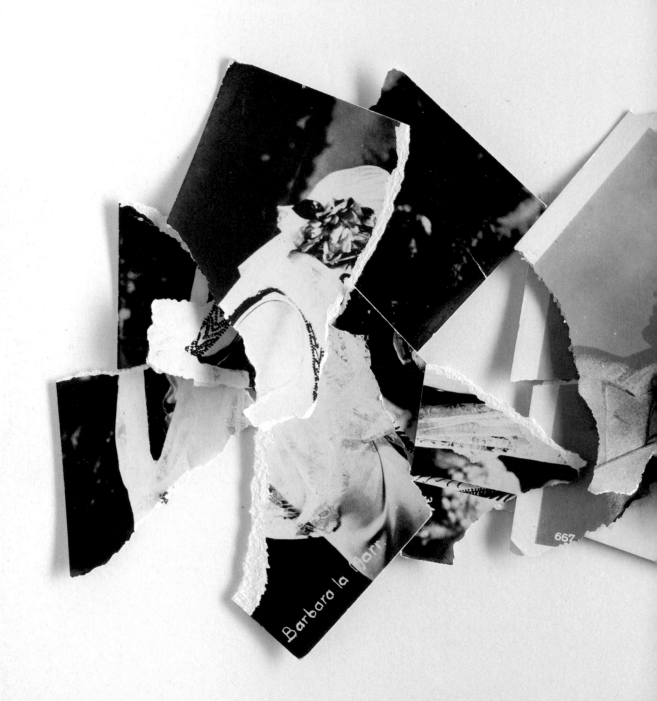

the Museum of Broken Relationships

by Olinka Vištica
and Dražen Grubišić

GRAND CENTRAL
PUBLISHING

Grand Central Publishing
Hachette Book Group
1290 Avenue of the Americas,
New York, NY 10104
grandcentralpublishing.com
twitter.com/grandcentralpub

First Edition: November 2017

Grand Central Publishing is a division of Hachette Book Group, Inc. The Grand Central Publishing name and logo is a trademark of Hachette Book Group, Inc.

The publisher is not responsible for websites (or their content) that are not owned by the publisher.

The Hachette Speakers Bureau provides a wide range of authors for speaking events. To find out more, go to www.hachettespeakersbureau.com or call (866) 376-6591.

Print book interior design by
Gary Tooth / Empire Design Studio.

Library of Congress Cataloging-in-Publication Data has been applied for.

ISBNs: 978-1-4789-7050-7 (hardcover); 978-1-4789-7051-4 (ebook)

Printed in the United States of America

Quad-Taunton

10 9 8 7 6 5 4 3 2 1

For anyone who has ever caught a flicker of love
and seen it disappear

Introduction

Olinka Vištica

I still remember fragments of that scorching summer more than a decade ago, when love slowly gave way to pain. In a house that seemed to have already been split down the middle, we took to sitting almost without speech at the kitchen table trying to overcome the feeling of loss and quietly surrender to the end of love. When we spoke, we spoke gently as if trying not to disturb the bandage on a newly opened wound. The physical remains of our four years together gawked at us from every corner of the house: a dusty desktop computer laden with photographs of happier times, books inscribed with dedications and failed promises, a VHS player that had witnessed cuddly movie nights long before the digital age. Even the kitchen table we sat at was loaded with meaning and memories that were doomed to fade away along with our shattered relationship.

What can one do with the frail ruins of a love affair? If you enter the phrase *broken relationship* into any search engine, in any language, you will be offered a series of self-help instructions describing how to unload your emotional burden as quickly and efficiently as possible. Self-proclaimed experts want to tell us how to get rid of every merciless reminder of our washed-out love, of yet another defeat, of yet another personal failure. Libraries and virtual space are flooded with advice for attaining oblivion. But is *total erasure* the only way out?

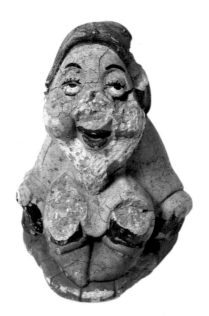

In the midst of the debris surrounding us, there was one trivial object that, in its own unlikely way, glued the shards of memory back together. We used to call the little windup toy honey bunny—a substitute for the pet we could never have, since we both traveled so often, and Dražen is allergic to cats. Now this banal symbol of the transient nature of our relationship seemed to offer an answer. That fluffy toy used to bring a smile to my face every time I came home exhausted from work to find it cheerfully marching in circles in the entryway. It became the first building block of the project that, miraculously, still ties us together. We came up with a simple idea: a place to

store all the painful triggers of past loves, creating a vault for both their tangible and intangible heritage. It seemed a nicer, more poetic solution than divvying up family possessions or, worse, giving in to outbursts of emotional vandalism, which would be bound to destroy invaluable parts of our intimate history. We named this repository the Museum of Broken Relationships.

Our museum was first introduced to the public in 2006 as an installation at a local art festival. A stranded ship container served as a harbor for forty objects of love's wreckage. The objects had been entrusted to us by both close friends and complete strangers, and we displayed them anonymously—the personal stories of their owners were the only text. Stories that had once had meaning to only two souls immediately resonated with an audience, strangers who recognized that heartache all too well. Soon thereafter, we were invited to set up installations in Berlin, San Francisco, Ljubljana, and Singapore and found ourselves venturing wholeheartedly on a thrilling journey down memory lane with no final destination in sight.

Our own breakup snowballed into what might easily be the most meaningful thing we ever created: an ever-evolving global collection of keepsakes, trinkets of no objective value, each of them a precious witness to the end of a relationship. In the years since, I have lost count of how many parcels stamped in Europe, India, China, Australia, or the United States (to name just a few of their places of origin) we have personally opened. At this point, thousands of objects have been wrapped and carefully tucked into padded envelopes by anonymous hands, most of which we will never have the honor of shaking in recognition, greeting, and gratitude. After more than forty amazing exhibitions in twenty countries, even after the establishment of museums with permanent addresses in Zagreb and Los Angeles, we still find ourselves puzzled whenever an unknown storyteller, from some near or distant patch of the planet, chooses to bid farewell to their love by sending their keepsake into exile, to a safe place for public commiseration.

Whatever their motivation for donating personal belongings—be it therapeutic relief, sheer exhibitionism, or a desire to immortalize the otherwise imperma-

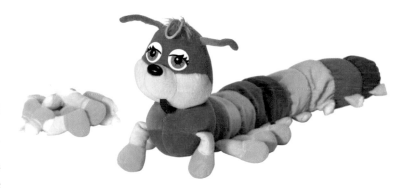

nent—people have embraced the act of exhibiting their emotional legacy as a sort of ritual, a solemn ceremony. Our society acknowledges marriages, funerals, and even graduations but denies us any formal occasion to recognize the demise of a relationship—despite the power that a breakup has to disrupt, or even shape the course of, a life. Thus, sending the object to the Museum of Broken Relationships has become almost a cathartic ritual, a final act in a person's process of coping with loss. The donors release their stories to us with the hope that their intimate confessions will resonate in the hearts of museum visitors; but what they may not suspect is the comfort and relief their stories offer to those who read them. A mundane object and its story, displayed in a public space, create a temporary comradeship of complete strangers, and

it feels like magic. It *is* magic.

We have often been asked if donating an object to the museum could be considered a kind of *therapy* for the donors and the museum visitors alike. Although we have witnessed people connecting, even in the most unexpected ways, with others' experiences and finding consolation in their grieving, we nonetheless shun the word *therapy*. It implies illness, the idea that there is something wrong with us that needs curing, as if simply taking the right pill would do the trick and fix everything.

We live in an era when something as complex, miraculous, and vital as a human encounter is often reduced to a status advertised on Facebook. We publicly display photographs of ourselves smiling, contented, bursting with optimism— almost as if we were trying to convince ourselves of their authenticity. Solitude, on the other hand, doesn't fit neatly into our social media. No wonder it rarely finds expression there. The complexity of its value defies conversion into an exact number of likes. The melancholic beauty that emerges from the rifts we experience during the course of our lives has been unjustly banished from the public conversation, in the same way that bags and wrinkles are erased by a Photoshop brush. We are left with an image of life that is nothing more than a touched-up portrait of happiness.

The objects presented in this book are far from touched-up. Ranging from the banal to the bizarre, they capture authentic snapshots of human experience from around the world over the last hundred years, often set against the political, ethical, and social challenges of the times. Whether the protagonists of these stories are engaged in battles across tiled kitchen floors or war-torn Afghan deserts, their stories never fail to enchant us. Each object's gripping power lies precisely in its rawness, in the courage and honesty of its former owners who chose to shed some light on the miraculous ways we love and lose. These diverse, often elliptical narratives span a gamut of emotions, from wry humor to deep grief, and they continue to provide a humbling experience, a source of inspiration, and a reminder to value those moments of true connection with each other, however brief or distant in the past they may be.

Contrary to its evocative title, the *Museum of Broken Relationships* is full of life, yearning, and hope. It is a tribute to the resilience of the human spirit, which is, luckily and amazingly enough, almost always ready to give love a new chance.

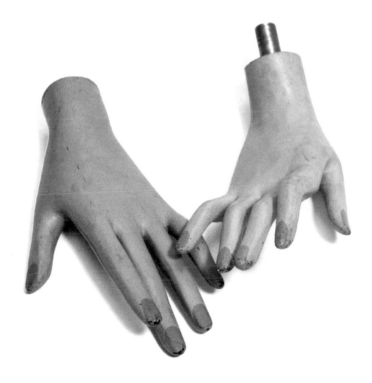

Wedding dress in a jar

7 years
San Francisco, California, United States

WE WERE TOGETHER for seven years, five of them married. Our wedding was a small casual ceremony near the ocean on the island where we lived. I wore a silk dress covered in butter-flies and flowers that I always thought I'd wear again but never did. He's been gone a year now and I haven't really known what to do with that dress. I hate throwing functional items in landfills but also don't really like the thought of someone else unknowingly walking around in something so representative of my broken dreams. I've put it in this jar because I like recycling but mostly I think it looks beautiful again taking on this new shape. It's a lot less sad when it's not hanging empty on a hanger. Plus I'm sure there's a metaphor to be found there somewhere.

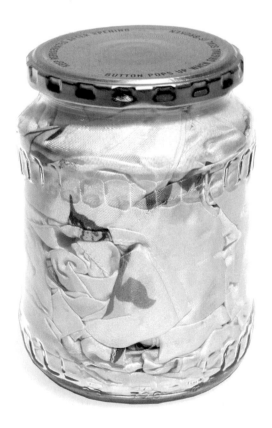

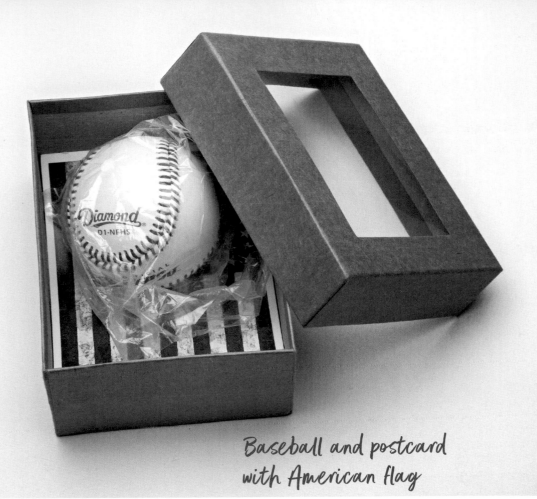

Baseball and postcard with American flag

April 15, 2010, to New Year's Eve 2012
Kent, Connecticut, United States

I READ THAT MATTER is incredibly, mind-bogglingly empty. If you could remove all the space between nucleus and electrons in every atom in the world, the compressed mass would be the size of a baseball. I mentioned this to my boyfriend who loved the sport, and he gave me this ball to use in an art project I hoped to create around the concept. I had lost both my husband and son within four years and was looking for ways to understand the universe. My boyfriend was a recent widower so I thought he understood grief. When I found out that he was sleeping with the wife of his coworker I wanted to take a bat and knock some sense into him.

Handmade calendar

3 years
Ljubljana, Slovenia

AT THE BEGINNING of our relationship my ex-girlfriend ripped all my posters off the wall during sexual intercourse, which was very hard for me to accept. This calendar was probably an attempt to repair the loss.

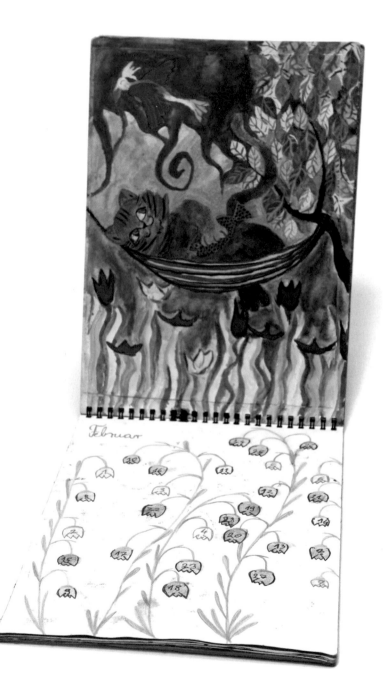

Olinka Vištica and Dražen Grubišić

A can of love incense

1994
Bloomington, Indiana, United States

DOESN'T WORK.

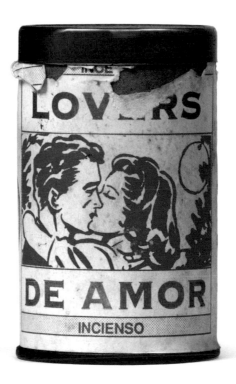

Feather sent in the mail

September 2009 to March 2013
Orange, Australia

MY PARTNER AND I lived in basically the same city, but there was a drive of an hour and a half between us, so our meetings were mostly confined to weekends. In the early stages of our relationship we made up for the distance and lack of face-to-face contact by using our wonderful postal system, sending increasingly elaborate packages to each other. He was often more creative and daring than I. Among my favorite packages were the rock and the feather. The rock simply said "I love you" on one side and on the other side he wrote my address and placed some stamps. We were both so amazed that it actually made it through the postal service that he then attempted the feather, which arrived in near perfect condition. We often wondered what the people working for Australia Post thought when they processed our packages. It brought us both so much joy.

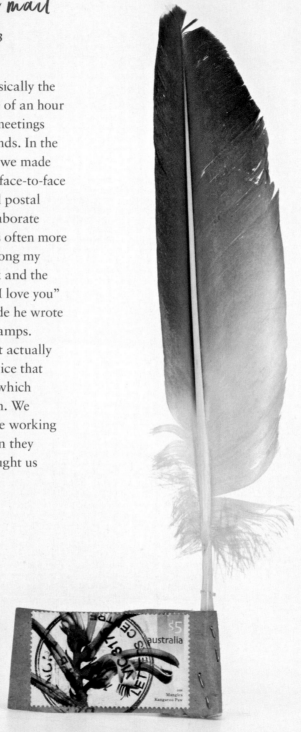

Brazilian banknote

2009 to 2013
London, United Kingdom

WE MET IN SCOTLAND. He made
a move on me. I felt uncomfortable.
He gave me his e-mail written on
a Brazilian banknote because he
said he didn't have any business
cards. I knew he was just trying
to seem cool. I never thought
about him and then he came down
south, to see friends, he said. I felt
sorry for him. We got married.
He took a lot of my banknotes.
And a lot more.

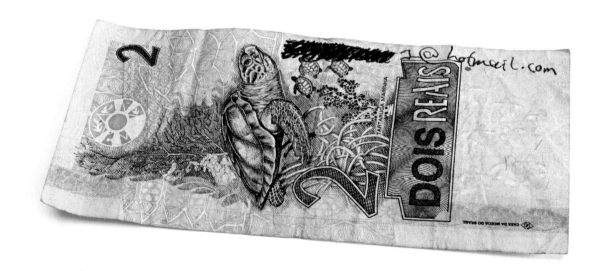

Love-letter piñata

September 1998 to January 2001
New York, New York, and Los Angeles,
California, United States

I DATED AN actor/musician long-distance for two
and a half years. He would never hold my hand
in public. Ours is still the best sex I ever had, even
though he has a small penis. A few years after we
broke up, I made a piñata from all his love letters.
I know it's a cliché, but it made sense at the time.
It has hung in my kids' room since 2007, and my
husband rolls his eyes whenever he has to dust it.

Olinka Vištica and Dražen Grubišić

Bob Dylan
Tarantula book

2 years
Sleaford, United Kingdom

GIVEN TO ME by an American
"boyfriend" when I was seven-
teen and inscribed "for [],
who charmed the savage wolf."
I didn't know that he would
hound my parents for years and
eventually have a sex change
and steal their name for his
new persona.

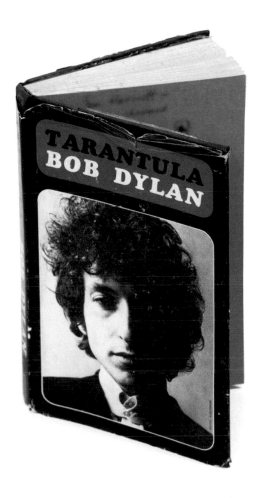

Child's pedal car

December 14, 2008, to January 9, 2011
Prague, Czech Republic

I WAITED ALMOST forty years to learn the meaning of the word *love*. Unfortunately, the intensity of our emotions carried us from one extreme to another. When we loved each other, we loved without holding back. When we fought, we fought till it hurt. Thanks to her I climbed a tree for the first time in my life, and I did it at a time when my children were climbing trees. We enjoyed making each other's dreams come true. Each dream fulfilled was a joy to both of us.

She knew that as a child I'd always wanted a car with pedals. But I never had one. I was over forty by the time one was given to me. She went for a walk with her sister, and there it was, next to a trash container. They brought it back to the apartment, put it in the tub, and washed it. They decorated it with little flowers and wrote my name, their nicknames, and the date on its wheels. This car represents our love. It shows that when two people truly love each other, no dream is left unfulfilled.

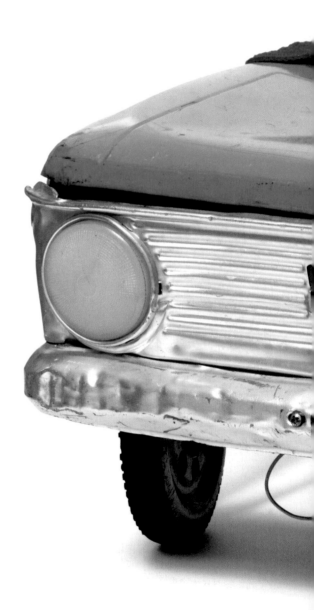

Olinka Vištica and Dražen Grubišić

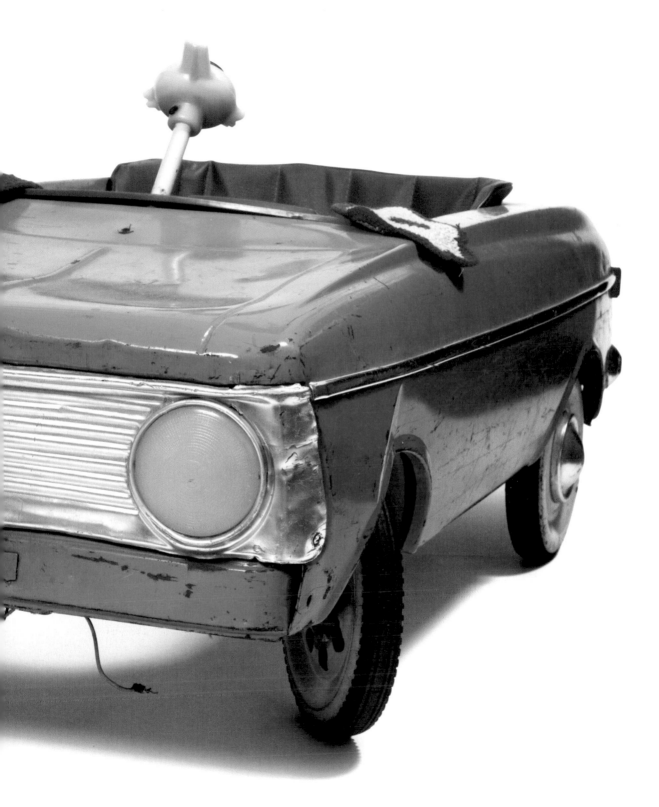

Stiletto shoe

1959, 1966 (6 weeks), and 1998 (a few hours)
Amsterdam, the Netherlands

IT WAS 1959. I was ten; T. was eleven. We were very much in love. When I told my mother we had gone skinny-dipping in the canal, I got my ears boxed and was sent to spend the rest of the school holidays with an aunt.

When I was fifteen, in 1966, we had more wonderful times together until he moved to Germany with his parents. Our goodbye came with many tears and promises: we would write every week and would never marry anyone else.

In 1998, I had just stopped working in prostitution, but I wanted to write a book about S&M, so I was working for a dominatrix for a few weeks. On the second day, the dominatrix allowed me to belittle and whip a client. First I made him lick my stilettos. He wasn't submissive enough and had the nerve to address me as "Mistress" (instead of "High Mistress").

I was getting ready to whip him harder when I recognized him. "T., is that you?"

He was startled and stood up. At once we were back in 1966. He told me he had the desire to be submissive because his father had often beaten him as a child.

T. was now in his second marriage, and he wanted to make it work. We both knew it would be better if we never saw each other again. After a few hours, as we said our goodbyes, he asked, "Can I keep one of your stilettos as a memento?" When he walked out the door, it felt like my bare foot was no longer mine.

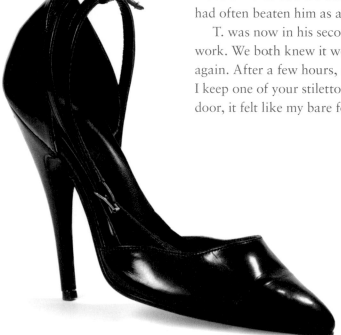

Olinka Vištica and Dražen Grubišić

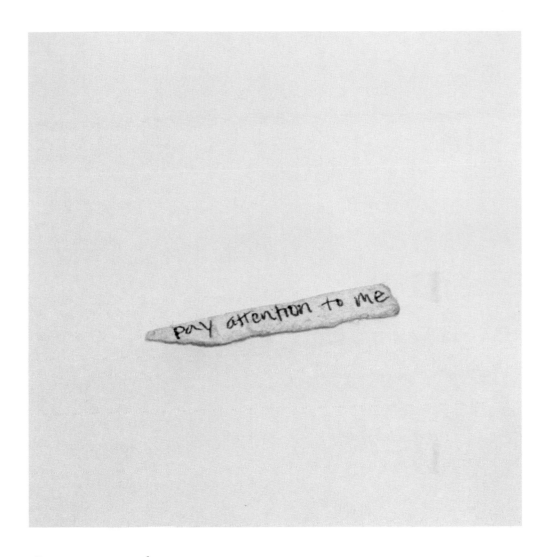

Tiny piece of paper

2001 to 2009
Los Angeles, California, United States

I AM AN ARTIST, and when my girlfriend and I lived together she would get antsy for my attention when I was working in the other room. One day when I was painting in our room, she came in and slid me a tiny piece of paper that said "pay attention to me." I found it maybe two years after we broke up, and it's been in the change compartment of my car ever since.

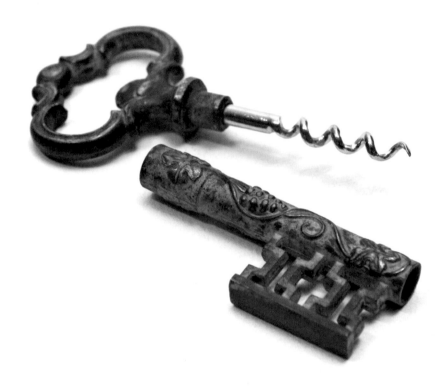

Key-shaped bottle opener

January 23, 1988, to June 30, 1998
Ljubljana, Slovenia

YOU TALKED TO ME OF love and presented me
with small gifts every day; this is just one of them.
The key to the heart. You turned my head; you
just did not want to sleep with me.

I realized just how much you loved me only
after you died of AIDS.

Wing ring

1 year
Cambridge, United Kingdom

I FLEW AWAY but could not find my way back…
I was blinded by the bright lights of other places
and other people.

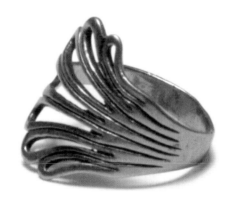

Rear drive sprocket

May 1, 2008, to November 13, 2013
Bergen, Norway

HIS MOTORCYCLE FAILED beyond repair a few months before our relationship ended. He started the engine one last time to burn the remaining fuel. Later, he told me it was heartbreaking to watch the motorcycle waking up eagerly, as if heading for a drive. When the last spark of life was gone, he let the carcass cool and picked it apart. He gave me one of the components, a rear drive sprocket. I didn't mind his new motorcycle, but I missed the old one.

In November he left me, saying he was in love with someone else.

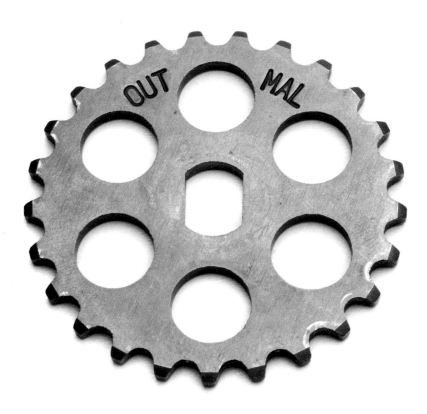

Olinka Vištica and Dražen Grubišić

Family Guy edition Uno game

2007 to 2012
Petoskey, Michigan, United States,
and Australia (long distance)

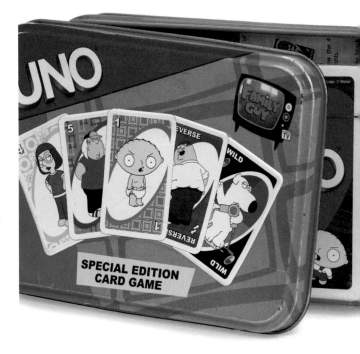

WE COULDN'T SEEM to catch a break. America would send me to Iraq right when Australia would bring you home, and then you would go off as I was coming back. Iraq was no place for a widowed mother of twins, but your skills as a trauma nurse were important to Australia, and you were too proud to back out of your commitments. I admired that. And so it went on—bad luck and our obligations as soldiers interfering with our desires as lovers.

This caught my eye after we talked one day of your love of *Family Guy* and your unrivaled skills at Uno. I hoped one day to play it with you and, of course, to win. I carried it in my bag to Iraq, and then with me to Australia when I got my R&R. We were supposed to play it then. Two weeks before I arrived, your "friend" raped you and nearly beat you to death. I spent eighteen days walking aimlessly around Brisbane in a fog while you alternated between saying you wanted to see me and feeling too ashamed to talk. Eventually I had to return to Iraq, and this returned with me.

We broke up but eventually gravitated back together. I was finally free of the military, and you were nearly finished as well. You asked me to be there in Australia when your flight came in from Afghanistan. There was nothing that would have made me happier. I came across this as I was packing and in the bag it went—finally we would have our chance!

Homecoming proved too overwhelming. You asked me to give you a couple of weeks while you sorted things out with your parents and your kids. I said I would be delighted, and took in the sights of Singapore and Indonesia while I waited for you to tell me to come. A few days became a few weeks, my e-mails and phone calls went unanswered, and finally I understood what I had spent so long ignoring—you were never ready to be serious.

And so I did what I knew best and continued traveling. In Zagreb, on your thirtieth birthday, I stumbled upon this museum and it was clear to me that what was perhaps the world's most traveled game of Uno deserved to end its nomadic life here. No regrets, only learning. May you find peace in your life, darling. You deserve it.

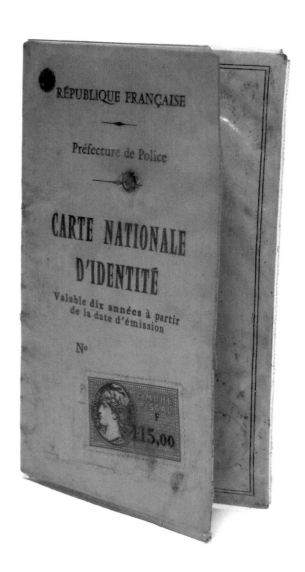

French ID

February 1980 to June 1998
Ljubljana, Slovenia

THE ONLY THING left of a great love was citizenship.

Olinka Vištica and Dražen Grubišić

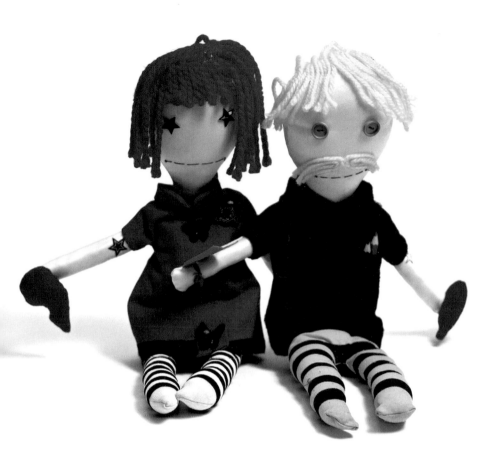

Our puppets

More than 10 years
Santoña, Spain

THESE PUPPETS WERE handmade by my ex-girlfriend, who gave them to me for my birthday. They represent the two of us. I have colored pencils on my shirt and a CD attached to my pants because I am an art director and musician. She has a sewing machine on her clothes because she is a tailor. Just like us, the puppets, too, have a star tattooed on the arm.

The gift also included two tickets for a concert by Bloc Party that we never attended.

Kissing-bunnies ring holder

January 25, 2002, to June 14, 2016
United Kingdom; California, United States;
Japan; Maryland, United States

THIS OBJECT USED TO sit on my kitchen sink and is where we would place our wedding rings when we did the dishes or cooked together. Recently my husband left me for another woman out of the blue. There were no warning signs. He just called me from six thousand miles away to tell me it was over. Now I have to carry on with my two small boys and begin to make whole new batches of memories in my kitchen.

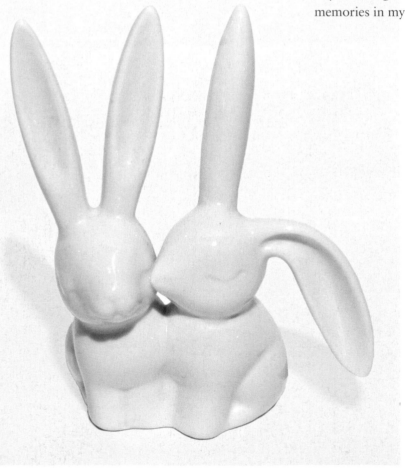

Olinka Vištica and Dražen Grubišić

Sweatshirt with a smiley face on the front and an angry face on the back

18 months

Copenhagen, Denmark

HE FORGOT THIS jersey at my place, and it reminds me of his two faces.

The smiling face that takes me out to dinner and tells me how much he trusts that I will never hurt him, how much he loves me and my reliable smile.

Then the angry face that tells me that he went to a South American transgender prostitute on Vesterbro and paid 800 Danish kroner for a blow job on Christmas Eve.

"Now we have gonorrhea," the face says.

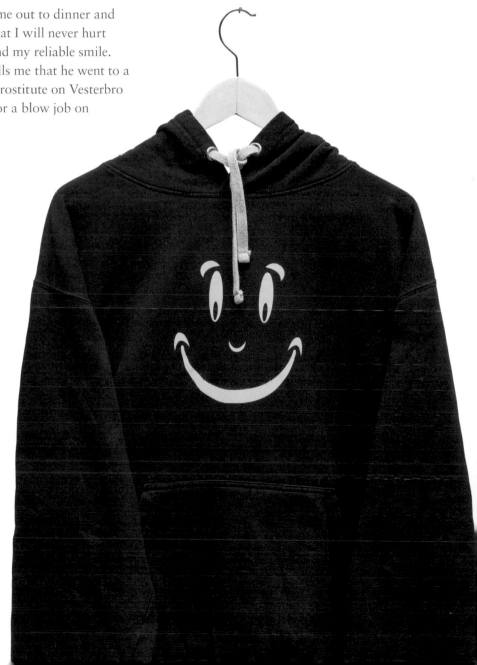

Champagne cork

2½ years
London, United Kingdom

I WAS DUE TO get married on
August 6, 2011, but discovered
six months ago that my fiancé
was cheating on me.

This is the cork from the
champagne I used to celebrate
my lucky escape.

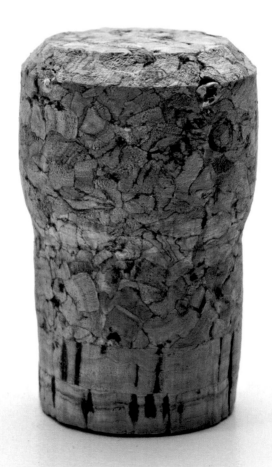

Olinka Vištica and Dražen Grubišić

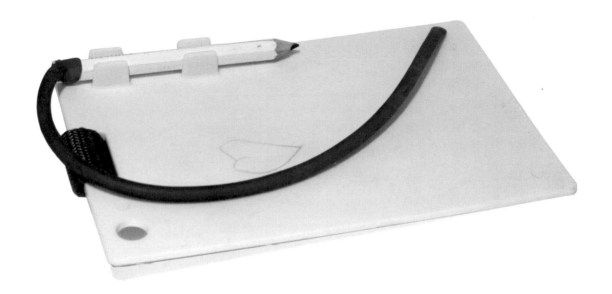

Underwater writing tablet

September 2007 to July 2009
Los Angeles, California, United States

WHEN I FOUND OUT my husband was cheating on me, I posted about it on Craigslist. I received dozens of responses, but only one wrote that he was going through the same thing. We met and started an affair. He was a scuba diver, so I took a course and became certified. We ended up diving together several times around Southern California and in the Caribbean. I used this slate to write him messages and we even took off our masks and kissed underwater. We remained together more than a year after my marriage ended; he was still with his wife when I broke it off but subsequently divorced and remarried. I haven't been diving since.

Vintage toy soldier

July 19, 2009, to September 30, 2010
Tucson, Arizona, and Boise, Idaho, United States

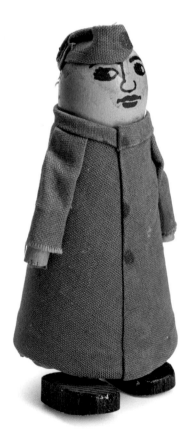

IN THE SUMMER OF 2010 we were preparing to move into our new house in Tucson, Arizona. We spent weekends at antique fairs and shops finding perfect things to fill the rooms. One day I stumbled across a little wooden soldier with a round head and a drab canvas overcoat. Ken was in the army reserves, and I liked the idea that this humble soldier would stand watch at our home when he was away.

A couple of weeks after we moved in, while we were still unpacking, Ken lost his job. He panicked. There were very few options for jobs in our area, and we could barely afford the house payment as it was. He started sleeping on a cot in his home office, often staying up nights to do job research.

He suggested we take a trip to do some scuba diving in Mexico over Labor Day, to relax, forget about our troubles over the long weekend.

We returned home to find our house flooded ankle deep—the tiny hose to the ice maker in the fridge had a hole in it and had been spraying water for three days. Nearly all of our belongings were waterlogged and ruined. The house was unlivable.

About a month later I found out that Ken had tampered with the hose—he had intentionally flooded our house for the insurance money. He had also taken out an insurance policy on my life just prior to our scuba trip. Had he planned to drown me in the ocean and lost his nerve? There were other deceptions, too. Those trips away, the ones where my little toy soldier was standing guard, were rendezvous with a former girlfriend.

I packed up my remaining belongings and moved back to Idaho.

Olinka Vištica and Dražen Grubišić

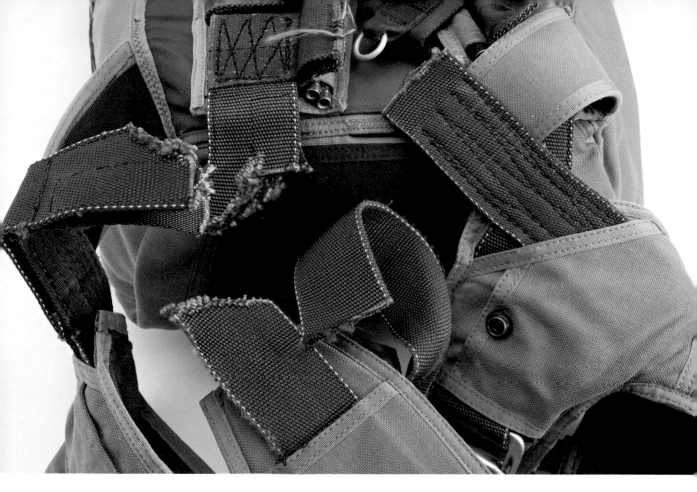

Parachute rig

3 years
Helsinki, Finland

I MET HIM ON my first parachute jump. I was really scared but this handsome man, who was my tandem jump instructor, "saved" me. Later, he helped teach me to jump solo. We loved to play in the sky, and we loved each other. Then he died in a parachute accident.

4 discs

May 2008 to January 10, 2009
Richmond, Virginia, United States

IN 2008 I WAS sixty-two; he was thirty-four. I was not looking for him; he was not looking for me.

The universe opened a door, and we walked through it. He gave me a magical time.

On January 10, 2009, I let him go. I let him go not because I wanted the magic to end, but because it was the best ending for a relationship that was destined to end since the day it began.

After I die, my family will be sorting through what's left behind of my life, and they will not find Mr. Thirty-Four. I've removed all the "evidence" and stored the memories in my heart, except for these four discs of music. Mr. Thirty-Four put this music together and gave it to me because he wanted to give me something important. He wanted to give me something he loved. He gave me music.

Giving these discs to you honors him, and it honors a broken heart.

Thank you!

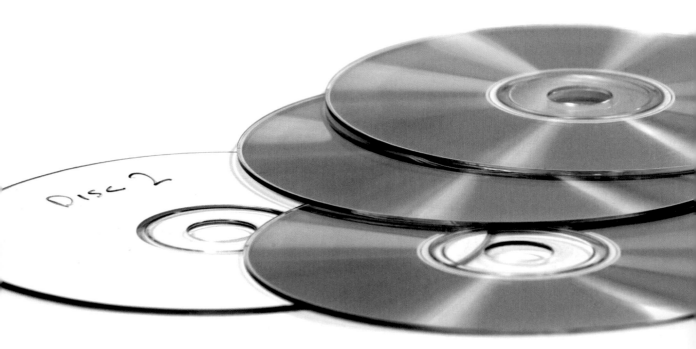

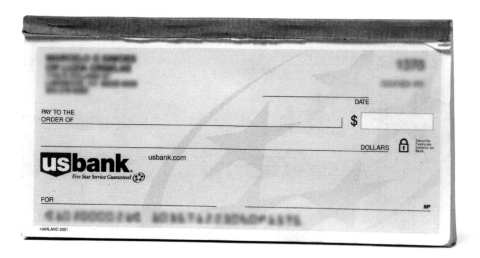

My last 2006 checkbook with my and my ex's names on it

1984 to 2006
Denver, Colorado, United States

I WAS IN LOVE FOR twenty-two years with my ex-husband, until he divorced me in 2006. I saved the last checkbook that I shared with him, as to me it represents the final and ultimate connection with him. It tells a story of, and is a record of, one of the most psychologically, emotionally, and financially damaging experiences of my life. This financial record reveals how we strengthened our family, traveled, and raised two beautiful kids. It also reflects our major purchases, paying for college tuition, and buying our dream home in America.

At the same time, the account tells the tale of how we managed to knock down and destroy everything that we had built. From this checkbook one will read how I paid several visits to two different psychologists, two psychiatrists, two lawyers, and one psychiatric ward. It also speaks of one car accident, one DWI, and the renting of two different apartments. In short, it chronicles the financial splintering of our time together.

For so many years I had to save it; I just couldn't throw it away. It is like destroying the power engine of a loving relationship.

Beauty

362 days
Reykjavik, Iceland

I met a girl by mistake…

she climbed inside my head

rearranged the furniture

and sat there with her

books and her cats.

She still haunts my mind…

my music and my books…

I have filled volumes…

blackened pages with bad

poetry and love letters and an

unfinished novel…

These are the only words she ever wrote to me.

Olinka Vištica and Dražen Grubišić

3-volume Proust

1983 to 2011
London, United Kingdom

THESE BATTERED, sand-strewn volumes are emblematic of a long love relationship that has recently ended. Soon after I married my wife, we got into an addictive Proust habit—I used to read the novel out loud to her, especially when we were on holiday. The bulk of it was read during successive summers on Tavira Island in the Algarve—we would walk out to an isolated stretch of sand, build a shelter out of driftwood, bamboo, and silk sarongs, and lose ourselves in the hypnotic prose with the dull roar of Atlantic breakers in the background.

I still think it's the best way to enjoy Proust—to get inside the head of the narrator and feel how his obsessions loop back on themselves, and to get the hilarious, laugh-out-loud comedy of the book—though it's hardly a practical one, as you need the best part of a decade to get through it all!

It sounds like a weird, nerdy thing to do, but it happened gradually, and some summers it felt like we were in a sort of ménage à trois, with Proust as the funny, neurotic third party, brilliant at rhapsodizing on the theme of love but never getting any of the sex.

Perhaps it's symbolic that, unlike Proust, we never got to the end—the last two hundred or so pages are unread, in an envelope, detached from the final volume to save on baggage weight.

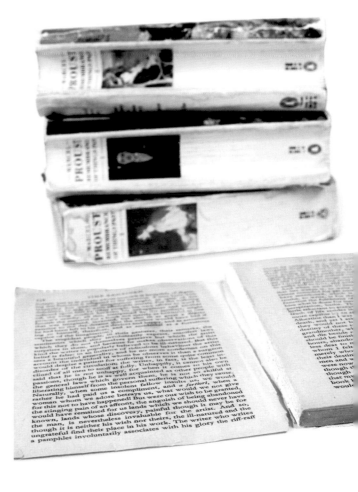

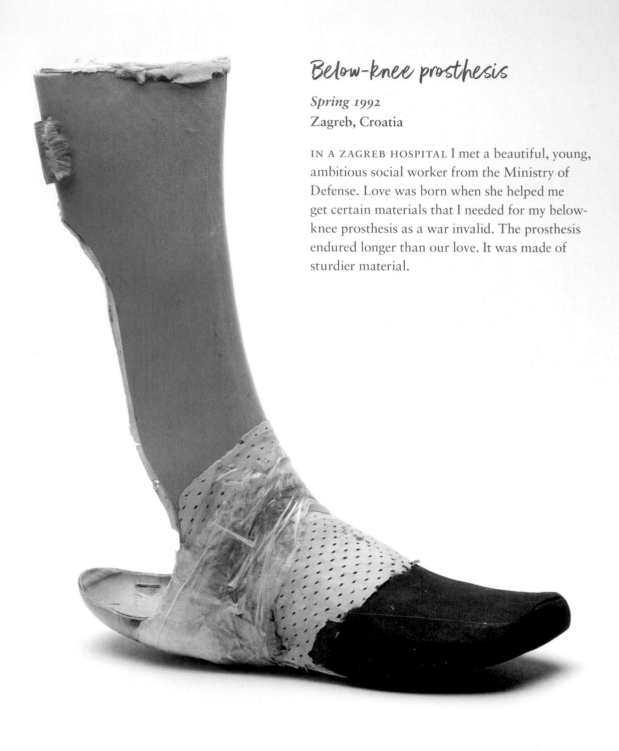

Below-knee prosthesis

Spring 1992
Zagreb, Croatia

IN A ZAGREB HOSPITAL I met a beautiful, young, ambitious social worker from the Ministry of Defense. Love was born when she helped me get certain materials that I needed for my below-knee prosthesis as a war invalid. The prosthesis endured longer than our love. It was made of sturdier material.

Sinners after six: A box of mints

September 2009 to March 10, 2010
New York, New York, United States

WHEN I SPOTTED HER across the crowded room, she locked eyes with me and playfully ran her hand across her neck as if she were slicing her throat. When I gave her a puzzled look, she mouthed the words *You are a serial killer.* She was as hot as she was crazy, and I was hooked from that moment on.

A year later she had a run-in with the cops and was sent to Rikers Island, where I visited her. Once released, she came to stay with me in my basement apartment. She was there, on and off, for almost seven months.

Even though I'd say things like "You know we can never be together," it was my hope that she'd protest. That never happened. Unbeknownst to me, she was also sleeping with another guy we worked with. They got married shortly after our last night together.

I'd given her so much. She gave me this box of mints. It was funny because her parents are born-again Christians, and my father is a Baptist preacher. "We are so bad," she'd boast over our short time together.

She's no longer married. That lasted about a year. We still keep in touch. It's always me reaching out to her, of course. "Don't you miss me at all? I miss you all the time" was the last drunken text I sent out, a month ago. No reply. Typical.

Still, I will always look back at her fondly. That was my first tango with a true sociopath. There were so many more to follow.

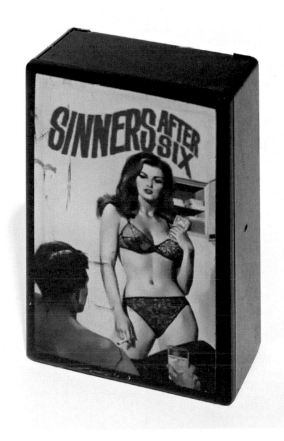

Magnifying glass

Unspecified time
Manila, Philippines

SHE GAVE IT TO ME as a remembrance before I left.

I never did get why she gave me a magnifying glass, nor did she ever explain what it meant.

But she always said she felt small whenever she was around me.

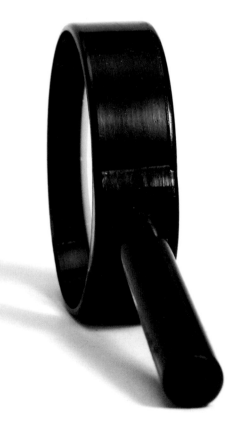

Olinka Vištica and Dražen Grubišić

Top 10 Reasons to Stay in the UK!
(in no particular order)

① Alton Towers - is quite good

② Europe is like 2 mins away, Italy, Portugal,
Spain - mmmm.... Food

③ My hair goes really frizzy in the Heat

④ I've heard that Australia is going to swept away
by wind in a couple of months anyway

⑤ I can't afford to post your (numerous) love letters
to Australia and also I would feel less guilty about
my carbon footprint if you were a bit more local

⑥ Lately, I've been finding lots more money than
usual on the streets of London

⑦ I'll cook for you naked alot

⑧ If you'd prefer I could keep my clothes on at all
times (save embarrassment)

⑨ I think that Australian's music scene has never
been the same since Brian MacFadden
went over there

⑩ I'm not good enough for you, but I'm sure I
must know somebody who is. Bella? She's coming
back to London YAY!

List of 10 reasons to stay

December 2011 (3 weeks)
London, United Kingdom

I MET HER AT THE beginning of December, not wanting anything
serious and definitely not looking for a girlfriend. After constant
contact I knew that she was something special, and her returning
to Australia on December 29 was not something I was looking
forward to.

So I wrote this list, but forgot to include number 11:
"These feelings don't happen to me often."

Steel handcuffs pendant

May 18, 2008, to December 27, 2011
Mexico City, Mexico

SHE WAS MY PSYCHOLOGIST for three and a half years; she told me she wouldn't treat me anymore; six months later, she looked me up and we started dating.

We lived together for a year and a half.

She gave me this pendant to show that our relationship represented a marriage. Our relationship ended because she never managed to come out of the closet.

I was twenty-two and she was thirty-six when we broke up. She now lives with a man, saying that she could never accept being gay.

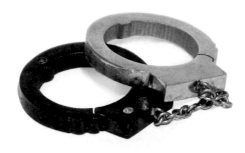

Olinka Vištica and Dražen Grubišić

Basketball shoes

September 2009 to September 2010 (1 year)
Seattle, Washington, United States

WE PLAYED BASKETBALL TOGETHER. He was straight; I wasn't. He used to tell me about the girls he was seeing, and it killed me inside.

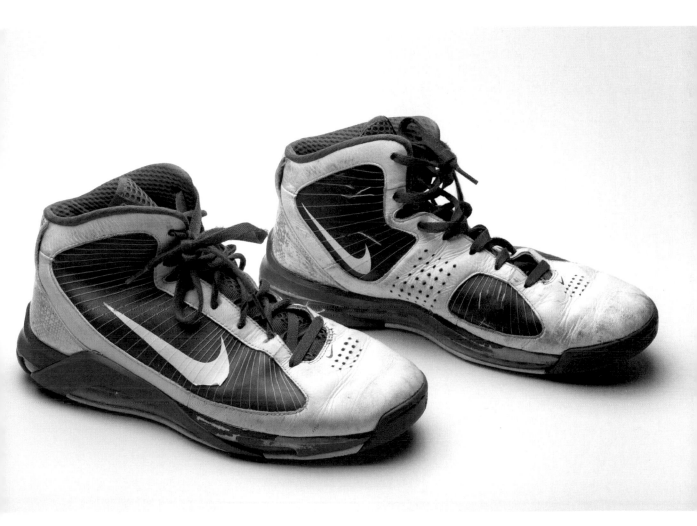

Spectrum of a star

1 year
Beijing, China

WE ARE BOTH astronomers. On my twenty-sixth birthday he sent me a spectrum of a star in the Orion constellation as my birthday gift. This star, named pi3, is twenty-six light years away from the Earth.

He said, "Look, at the time when you were born, the light left this star, passing through the endless interstellar space, the countless dust and nebula, arriving here after a twenty-six–light year journey. So have you. Here you meet your star-light, and I meet you.

Olinka Vištica and Dražen Grubišić

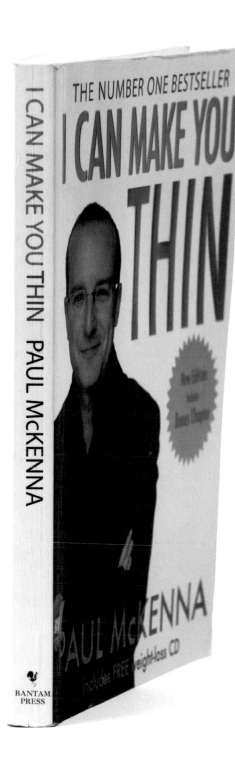

Book—Paul McKenna,
I Can Make You Thin

4 years
Horncastle, United Kingdom

THIS WAS A present from my
ex-fiancé… Need I really continue?

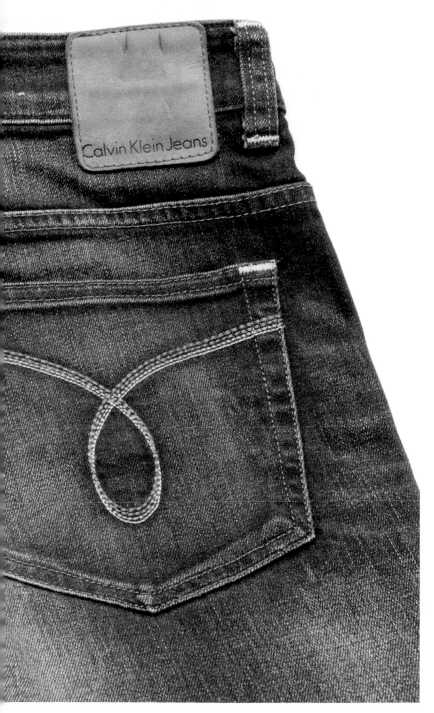

Pair of jeans

Forever
Seoul, Korea

I THINK I HAVE struggled with weight my whole life, under constant pressure from family, friends, and society to be thin.

I tirelessly exercised and dieted, trying to lose weight. But it never lasted long, and I would always end up overeating or yo-yo dieting. It was hard.

I am now finally giving up on reaching that dream weight. I am much thinner than before and I don't want that kind of stress in my life anymore.

I am donating a pair of jeans that are too big for me now. I want to bid farewell to that part of myself that always stressed over dieting. I want to focus on other things in life.

Silicone breast implants

2009 to 2013
**Los Angeles, California, and
New York, New York, United States**

MY EX HAD convinced me to get breast implants. He would continually comment on how he was a "boob guy" and allude to the idea that my natural breasts were not big enough. At the time I hadn't had enough therapy to tell him to go fuck himself; and over time I began to believe that my breasts were inadequate. I got silicone breast implants which he initially paid for, but then he made me pay him back. I had these implants in my body for five years. Some of the years with him, and some without. I hated them the entire time.

They not only caused me emotional trauma, but they ended up physically traumatizing me as well. My body rejected them from day one, and in the first year I had two surgeries: one to place them in and one surgery for revision. They would not sit properly in my body. In the second surgery, the surgeon decided to detach nearly my entire pectoral muscle from my sternum. I had no idea it had been cut so far and that eventually led to a rotator cuff injury as well as causing the implants to rise higher and higher on my chest. I looked like I had on an insanely high, hard push-up bra at all times.

I finally decided to have the implants removed to reclaim my own natural, beautiful body, and to close the door on any leftover influence that ex

had on my life. The removal surgery was arguably more intense than the other surgeries. It was a complete reconstruction of my breasts, as well as having to repair my pectoral muscle. Apparently my pecs were cut, rolled back, and sutured by the previous surgeon. So the current surgeon had to undo the sutures, unroll, and stretch the pectoral muscle, and then sew it back to the bone.

Ouch. I mutilated my body for a man I loved. At the time I loved him more than I loved myself, which I now know is very toxic. You need to love yourself fully and completely before you can truly love another. I am so much happier since having these removed.

The surgeon was so surprised and amused by the fact that I wanted to keep these, but how could I not? They have marked such a huge emotional journey for me. Part of me wanted to mail the implants to my ex in a box with a note that said "I'm finished with these." But as funny as that would be, I think this seems to be a much better and a much healthier idea. What a beautiful send-off for these two lumps of silicone that caused me so much pain.

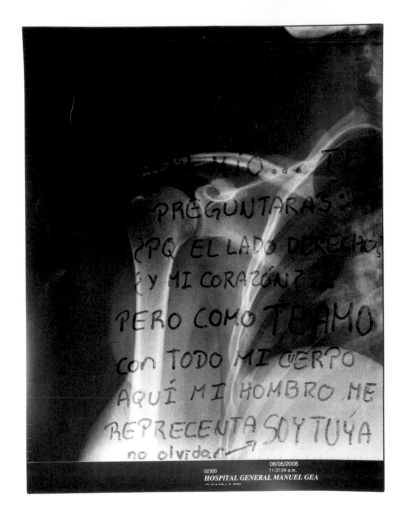

X-ray

June 2006 to December 2009
Mexico City, Mexico

BARBARA WAS MY FIRST. She was my first girlfriend, my first serious relationship, my first love. Our relationship was as intense and passionate as it was strange and destructive. One day we had a bad car crash, and we had this X-ray taken. For my birthday (08-08-08) she gave me one of the X-rays of her right shoulder on which she had written, "Andy, my love... You may ask why the right-hand side and not my heart? But since I love you with my whole body, my shoulder represents the whole of me. I am yours— Don't forget."

That cheap bitch.

Olinka Vištica and Dražen Grubišić

Dreads

October 2001 to August 2008
Alfortville, France

A 102-DEGREE relationship that ended as a supernova and left a huge black hole… Those were difficult days—those were dangerous days.

Centipede called Timunaki

Almost 2 years
**Sarajevo, Bosnia and Herzegovina,
and Zagreb, Croatia**

I HAD THIS BIG, truly big love: a long-distance relationship between Sarajevo and Zagreb. It lasted for twenty months. Of course, we dreamt of a life together and, with that in mind, I bought this huge centipede. Every time we would see each other we would tear off one leg. When we ran out of legs to tear off, then it would be time to start a life together.

But, as is often the case with great loves, the relationship broke and so the centipede did not become a complete invalid after all.

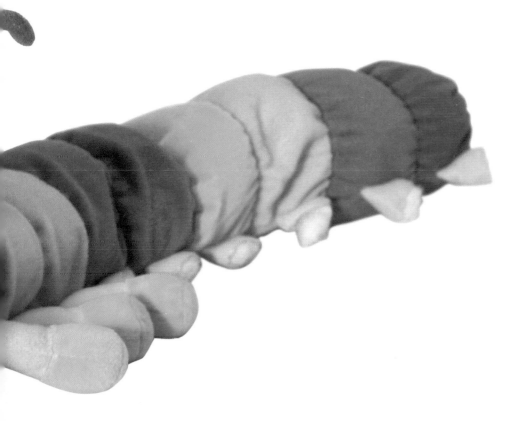

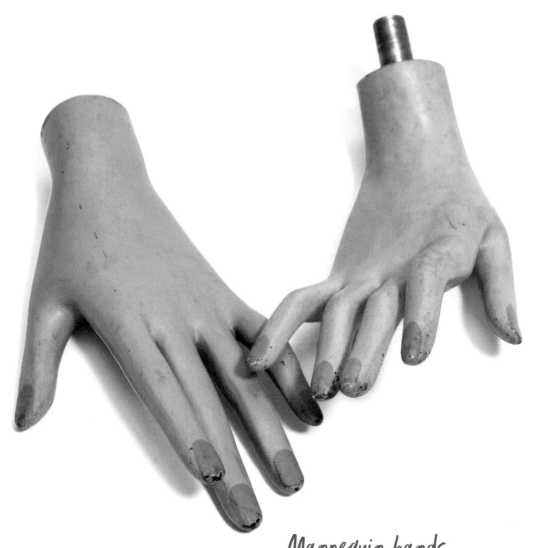

Mannequin hands

5 years
Berlin, Germany

I COULD NOT take any more than five years of a love-hate relationship. One night I left my room and did not come back until the next morning. I found it completely destroyed, sprayed all over with polyurethane foam. Total chaos. My favorite mannequin had no choice but to believe it.

Olinka Vištica and Dražen Grubišić

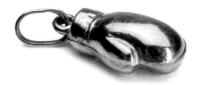

Gold boxing glove pendant

1995 to 2014
Middlesbrough, United Kingdom

WE WERE STUDENTS when we met. We spent that night talking until dawn. Both of us were carrying our hurts, and together we helped each other to overcome them.

This was the first birthday gift you gave me. "Happy 22nd birthday, Matthew." Boxing had been my passion since the age of eleven. The gift was perfect.

Fast-forward. 2014. Approaching forty. Marriage; two wonderful, beautiful children; good times and bad; and the distance growing between us as our paths diverged. Shock, sadness, and hurt, but no regrets. Without you I wouldn't have moved to London, and my career would not have led me to where I am now: working in boxing and following my passion every day. Thank you. And for the two brightest lights in my life, thank you. Step by step, I move forward without you, as you walk on without me. What we had was special; it was ours, but it was no longer enough. That hurt, but you're right. I truly hope you find what you are looking for. Don't settle for less than you deserve. Follow your heart. Be happy.

Plastic painting of St. Francis

"Until Death Do Us Part"
Basel, Switzerland

WHEN I WAS A CHILD, my father lived with us sporadically. He would come, and after a while he would pack his stuff and go away again. Every time, my mother said to me and my sister, "Your father is like a beautiful bird. We must rejoice over him when he is here, but we must let him fly away again." I did not actually understand this.

Once our African cleaning lady gave us this plastic painting as a present for Christmas. My mother found it kitschy and wanted to throw it away. But I kept it in my room, because the man in the picture reminded me of my father. When we moved to Switzerland, I took it with me.

I saw my father for the last time in the summer of 2010. Now I am definitely letting the bird go.

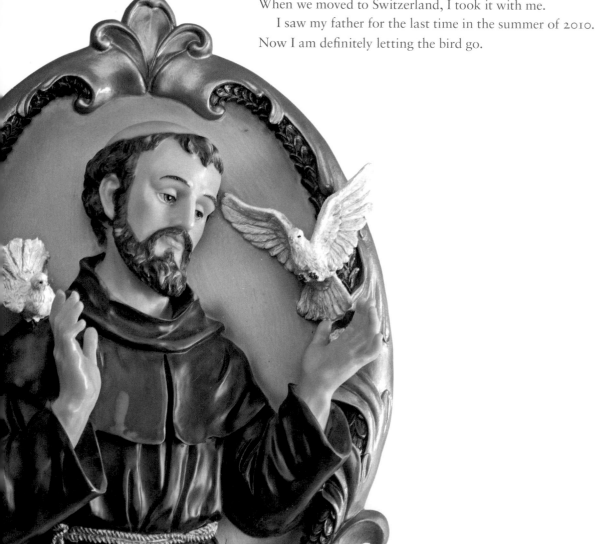

60 pages of handwritten travel diary, bound and sealed

September 1987 to December 1994
Copenhagen, Denmark

THE MEMORY OF the only summer, we were happy together, when you were 100 percent in my focus. The way you changed, when we got married and had small sick children, and my focus was on their special needs, broke my heart.

Destroyed VHS tape of my father's wedding

Mid 1990s to 2009
Denver, Colorado, United States

MY PARENTS DIVORCED after twenty-six years of marriage, and, soon after, my father began seeing a woman from his office. She saw a meal ticket, hunted him, married him, and then promptly quit her job, never to work again. He continued to work full-time, retired, and then went back to work to pay for her endless spending. She began a pattern of sleeping all day and then spending her nights buying senseless items from the Home Shopping Network. She ruined him both financially and emotionally.

When he was diagnosed with terminal cancer and given one month to live, her hoarding habits barred him from any hospice services in his own home. His insurance, however, didn't cover hospice facilities, only the care. She then tried to put him in a home for the indigent, refusing to allow him to use his own retirement savings to pay for his hospice care as this would "cut into the money I get when he dies," she said. My mother, the jilted ex-wife, and his ninety-one-year-old mother took it upon themselves to pay for his $1200-a-week care. The already-strained relationship only got worse as time progressed. We were all advised by the hospice staff to avoid any contact with his wife. When my father passed away, not only did I refuse to go to his funeral, to avoid this awful woman, but my only sister, his only two siblings, his ex-wife, and his own mother also refused.

I was shocked (and horrified) a few years later when I found this tape of his wedding. I called my sister and we agreed—the tape must die. What you see has been run over with my car, stabbed with a screwdriver, shot several times with a rifle, sawed in half, chopped with an axe, and torched. Killing the tape was highly therapeutic.

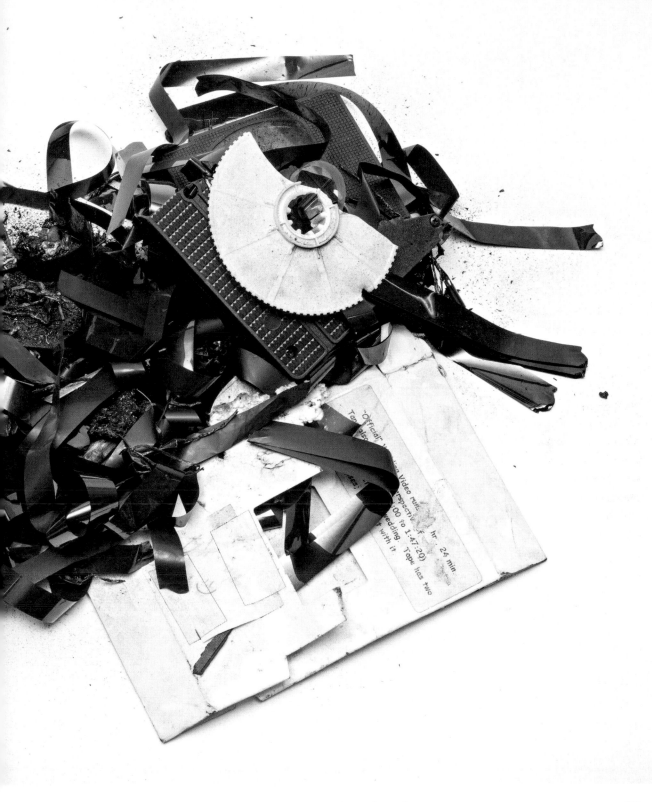

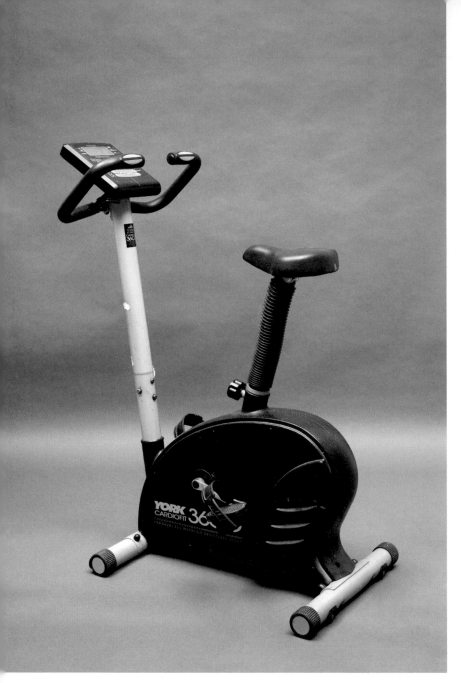

Exercise bike

14 years
Nurmijärvi, Finland

THIS EXERCISE BICYCLE was
originally a Christmas present
for my wife.

It has preset programs such
as Cardiofit and heart recovery
(not working). When I found out
that my dear wife likes to ride
much more than just the exercise
bike, I divorced her. She didn't
want to take the bike with her;
I assume that her heart is in
good condition.

Gingerbread cookie

1 day

Chicago, Illinois, United States

WE MET IN THE MIDDLE of Oktoberfest. I'm an American diplomat, he a bloke from Liverpool working in finance in London. We connected easily and ditched our friends to hang out alone for a while. As soon as we left the biergarten tent we started laughing like kids, going for rides, dancing, and singing, and we really connected. I did not want a long-distance relationship, but after much persuasion I gave in, and we exchanged details. A few days later I received this text: "Stephanie, it is hard for me to say this to you as you are a great girl, but could we leave the 'friends' thing, please? It is true I am engaged with two kids and going through a bit of a tough time, but I know in my heart I love her and want to make a go of it, having a good-looking single 'friend' will only make that a whole lot harder to work out in my head, I feel. Many thanks for a great time I will always remember it, please don't phone or text as I fear it would only cause trouble. I Have a great life. P. ('Liverpool')."

Shaving kit

1987 to 1996
Zagreb, Croatia

SHE BOUGHT ME this shaving kit for my birthday. I haven't used it for quite some time now, but I've kept it as a memory of her.

She was seventeen when we met; I was twenty-seven, married, with three children. We broke up after ten years, but the love on my side is still as strong as it was back then. In the meantime, she got married and had one daughter. I hope she doesn't love me anymore. I hope she doesn't know she was the only person I've ever loved.

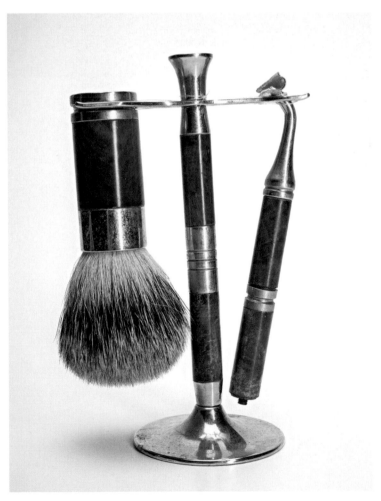

Olinka Vištica and Dražen Grubišić

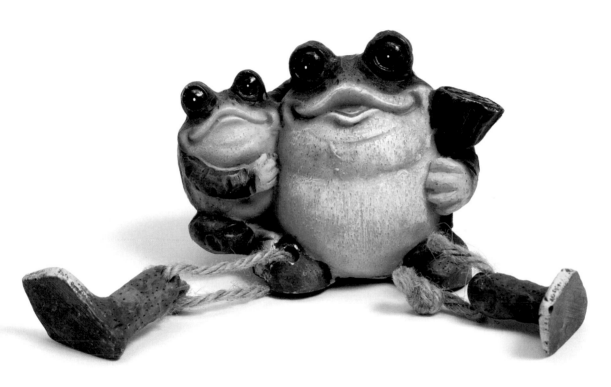

Frogs

36 years
Bloomington, Indiana, United States

MOM LEFT WHEN I was three. This is one
of the few Christmas gifts she has given me.

My mom's personal belongings

She died in 2006
Warsaw, Poland

WE WERE LIKE SISTERS. I would often be the one accompanying my mom, not my dad. He was left out, I never learnt why.

She was there every second of my life. Wanted. And unwanted. It is very difficult to have an awareness of your relationship with your child when she's your only child through necessity, not choice. And it is very difficult to constantly bear in mind the fact that your mother is ill, has always been ill, and that the illness will eventually win.

The first tumor grew even before I was born. The last one came when I was twenty-four. Twenty-five years of constant fight. We all fought. I will always be amazed by her strength, the will to live, to love, and to be loved.

But if I want to stay sane, come to terms with the fact that I am also genetically prone to cancer; if I wish to finally end my mourning and simply remember what was beautiful; if I want to live my life not hers, I need to let go.

This is my letting go.

The shoes—she liked them so much that she never wore them, so as not to destroy them in any way. The dress—she was eighteen when she made it herself; it fit her beautifully even for her fortieth birthday party! The suit—she looked so sexy in it but was so afraid of that look. The purse—I found it only after she'd died. I loved it, but still, it is hers, not mine. It has to stay that way.

Mom, I am sure you found your freedom. Now I am claiming mine. For the sake of my husband and my children. For my dad. Goodbye.

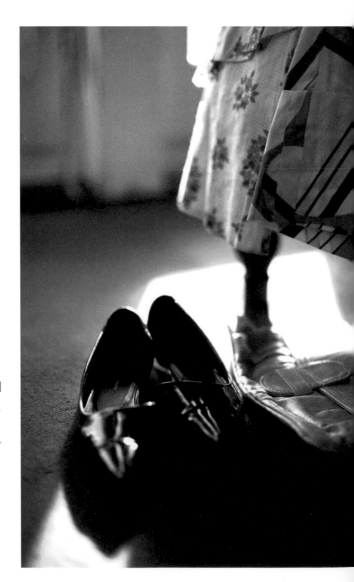

Olinka Vištica and Dražen Grubišić

Postcard

1919 (1 month)
Heidelberg, Germany, and United States

MY GRANDMOTHER'S MOTHER was a beautiful young lady in 1919. Her life at that time was one large party and each month she got to know a new young man. But only two of them were important to her: her father and her German lover.

She lost her heart in Heidelberg. The lovers were together for a month. Once they watched the sun go down at the castle. He did not come to America with her. He had no money, and her parents did not like him. But each autumn he sent her a postcard.

Here is the last postcard from her German lover. We believe that he died in the Second World War.

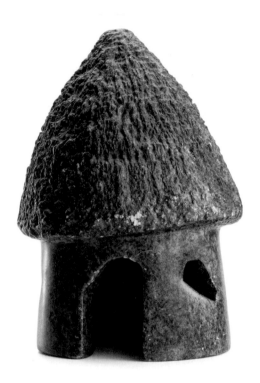

African stone house

43 years
Basel, Switzerland

WE "ACCIDENTALLY" CROSSED each other's path on a beach in Zeebrugge. He was sixteen and had four brothers and sisters. He was from Holland. I was also sixteen, also had four brothers and sisters, but came from Switzerland. We were both half-orphans, our fathers died of cancer in the same year.

A special friendship began. Over forty-three years we exchanged endless letters, but met only five times. Until for my fifty-eighth birthday my oldest daughter paid for a trip to Amsterdam as a present.

Fearless and cheeky, I rang his doorbell. Without saying a word we stood face-to-face.

Having both aged, we examined each other… deeply touched.

He: "Are you here to say goodbye?"

Me: "No, why?"

After a long hesitation he said: "I had a dream in which you were gravely ill from cancer."

Six months after that I was diagnosed with a malignant tumor. This was five years ago. Since then we have had no contact.

That is why this African cabin (with the inscription "our second home"), which he has hewn in stone during long hours, should now get a special place.

Olinka Vištica and Dražen Grubišić

Antique watch

1987
Zagreb, Croatia

SHE LOVED ANTIQUES—as long as things were old and didn't work. That is precisely the reason why we are not together anymore.

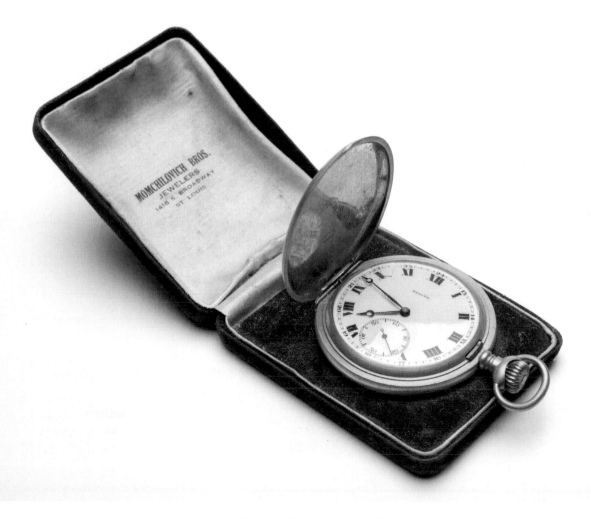

Broken trunk

September 2010 to March 2012
Mexico City, Mexico

HE AND I DECIDED to have a trunk to keep our secrets hidden from others. Over time it was filled with photographs, tickets, lingerie, letters, and sex toys. The key was a bracelet that we used to keep with us at all times. At the time of our breakup I threw a party at my house. Everyone we knew was there. Angry and drunk, he took the trunk from my bedroom and threw it against the floor. All the contents came flying out for all my friends to see. There were no secrets between us from that day on.

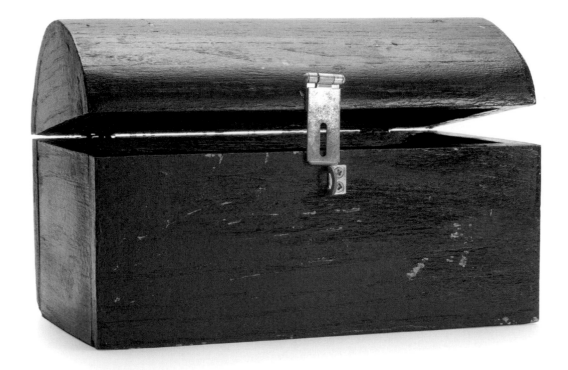

Olinka Vištica and Dražen Grubišić

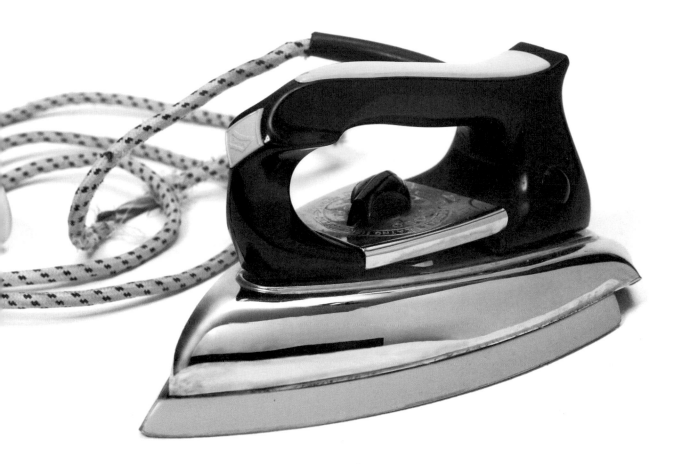

Iron

Unspecified time
Stavanger, Norway

THIS IRON WAS USED to iron my wedding suit. Now it is the only thing left.

Vintage Stratton compact

September 1999 to May 2002
Durham, North Carolina, United States

MY HIGH SCHOOL BOYFRIEND stole this compact for me from a vintage store along the North Carolina coast. It was less than a year into our tumultuous relationship. I wasn't living at his house yet; we hadn't yet figured out how to drive each other crazy. He had just gotten his driver's license, so we did what troubled sixteen-year-olds do: skipped school and drove two hours to the beach. It was early spring and colder than we had anticipated, so rather than getting high and making out on the sand, we hotboxed his Ford Taurus then wandered around the cute shops downtown. I saw the compact on a shelf and commented that it was lovely. I didn't see him pocket it and was surprised when he gave it to me a few hours later, wrapped up in wrinkled notebook paper.

I left him right before high school graduation, after he threw a chopping knife at me, and after I was accepted into college and knew that I'd have a place to live without him.

For the past thirteen years I have caringly wrapped the compact in paper every time I've moved. I don't use foundation (or powder, whatever is meant to go in there), so the compact has gone empty ever since he gave it me. Which seems fitting—our relationship was a failed attempt at filling the holes we had inside us.

Olinka Vištica and Dražen Grubišić

Piece of candy

October 2015 to August 2016
Doha, Qatar

IT WAS SUPPOSED TO BE a safe affair: two people in a foreign land, both married to others and separated by distance. We were from different races and completely different cultures. I did not want to love him. He treated me worse than any man I have ever known, and he also brought me immeasurable joy: the sight of him, his smell, the sound of his voice, and the feeling of being with him. He disappointed me so many times, but I always went back for more.

In the end, I took back my power and walked away. I will not be treated as a *sharmuta*. He is across the world, and I will likely never see him again. He is a dull ache in my heart and the sadness no one sees.

This piece of candy is the last artifact that I have from my time with him. I have no idea why I saved it, or brought it home from seven thousand miles away.

You are always close to my heart, *habibi*, but I will not be torn apart for love.

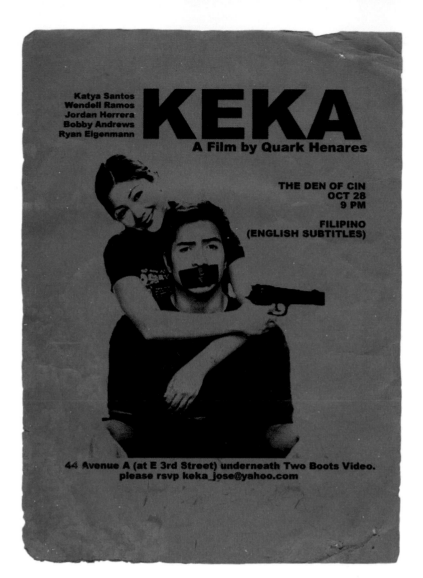

KEKA

Katya Santos
Wendell Ramos
Jordan Herrera
Bobby Andrews
Ryan Eigenmann

A Film by Quark Henares

THE DEN OF CIN
OCT 28
9 PM

FILIPINO
(ENGLISH SUBTITLES)

44 Avenue A (at E 3rd Street) underneath Two Boots Video.
please rsvp keka_jose@yahoo.com

Keka Flyer

October 2003
Manila, Philippines

TO CELEBRATE the release of my new movie, *Keka*, my then-girlfriend and I decided to go back to where our relationship had begun—New York. Unbeknownst to me, she bought a pirated copy of the film and worked for weeks to subtitle it herself. She then organized a screening in an underground theater we used to live near, and she invited friends, family, and even artists I admired but didn't really know. It was her surprise to me on my twenty-third birthday, and the sweetest thing anyone has ever done for me.

Olinka Vištica and Dražen Grubišić

Decorative medal

July 2011 to April 2014
Boston, Massachusetts, United States

MY BOYFRIEND AND I had a very happy polyamorous relationship, until he started dating and subsequently became the sole source of support for a very nice but mentally and physically unwell woman. His relationship with her drained away all of the effort he had previously spent on ours, and he became outraged when I pointed this out. As our relationship was crumbling, he decided that he needed to move across the country for professional reasons, and that he wanted us both to come with him. I was hesitant, especially because she had already said yes (despite having been with him for only three months). When I hesitated to uproot my entire life for an unstable relationship, he took it very hard. We fought and broke up.

A few weeks before they left town, he and I had lunch, and he gave me this medal—from both of them—"for being awesome." Apparently I hadn't made our breakup as dramatic as I could have, and for this, I deserved an award. It was heartbreaking and infuriating, and I never even took it out of its little plastic bag. I can't keep it; it reminds me of how much we stopped seeing the world in the same way toward the end.

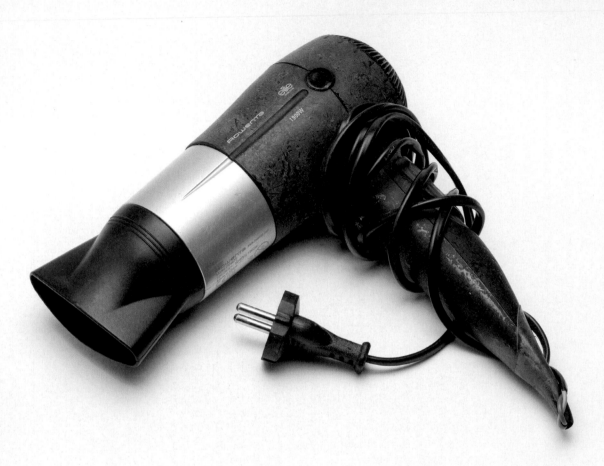

Hair dryer

9½ years
Cologne, Germany

WHEN I WAS a child, my family used to have a "special" hair dryer. Because it would overheat, once it had been switched off it sometimes took a while before it could be used again. So we tended not to switch it off whenever several family members needed the hair dryer.

During our relationship, my ex-boyfriend usually took his shower first, and used the hair dryer before me. Although it was not the same hair dryer, I often asked if he could hand the running hair dryer over to me... He turned it off instead.

Olinka Vištica and Dražen Grubišić

Boyfriend hat

2000
Cape Town, South Africa

SHE ALWAYS CALLED IT that; said she liked it because it looked like a man's hat, but it really suited her. I only found out two weeks ago that it was her boyfriend's hat, and she was still sleeping with him.

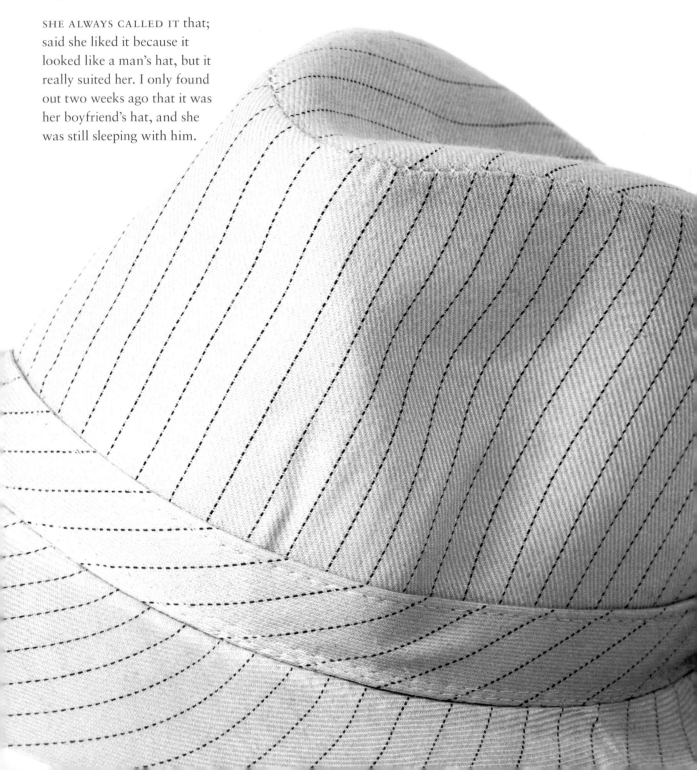

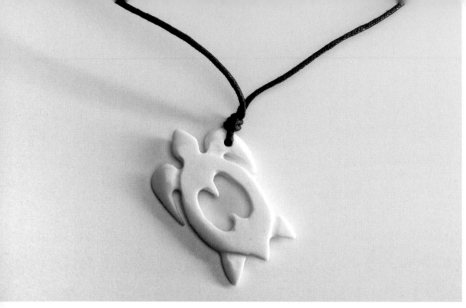

Sea turtle pendant

November 17, 2012, to December 29, 2014
Berkeley, California, United States

"I BROUGHT YOU BACK SOMETHING from Hawaii," he said. He had been to Hilo visiting his wife, who lives there.

It was a sea turtle pendant, very stylized, on a black cord.

"I love it," I said. "I've never seen anything like it."

"I thought you'd like it," he said. "It's from a little shop near our house. Very unprepossessing, but has really interesting things."

Just before Thanksgiving he hosted a dinner party at his home in Berkeley. When I arrived, his girlfriend opened the door.

"Come in," she said.

"I like your necklace," I said. "In fact, I have one just like it."

She laughed, fingering the sea turtle pendant around her neck. "Makes sense," she said. "Just think how much time it saves, buying both girlfriends the same thing."

Her amusement showed she could handle loving him in a way I never could. A necklace can be mass-produced, but each human heart is unique.

Olinka Vištica and Dražen Grubišić

Holy water bottle shaped as the Virgin Mary

1988 (2 months)
Amsterdam, the Netherlands

IN THE SUMMER OF 1988 I met my transient lover in Amsterdam. He had a stopover during his travels. He was from Peru and was discovering Europe by train. We met at the Buddha disco. Not long after that we bumped into each other on the street, and he went home with me and stayed for about two months. Suddenly he was gone. I found a goodbye note and this little statue, which he said he had specifically brought from Peru in the hope of meeting a new love. What he didn't know was that I had once opened his bag and found a whole plastic bag full of these bottles. I never saw him again.

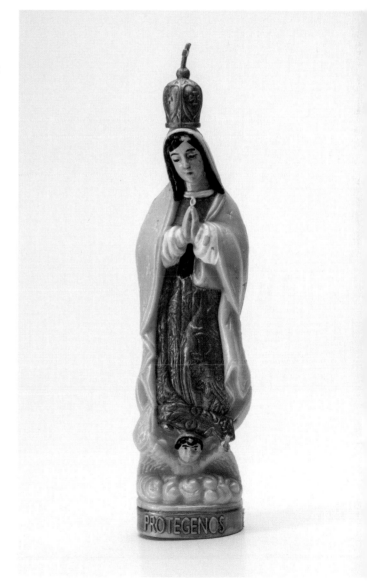

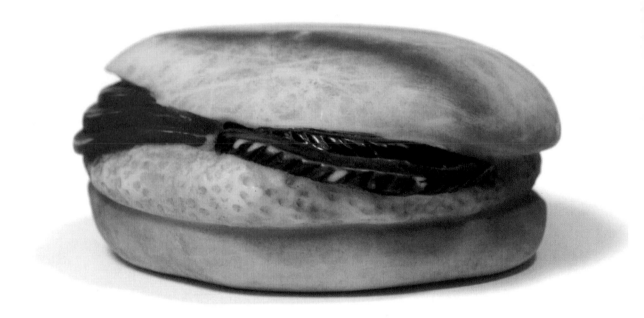

Hamburger toy

2011 to 2012
Differdange, Luxembourg

HIS DOG LEFT MORE traces
behind than he did.

Olinka Vištica and Dražen Grubišić

Batch of German children's books

1990 to 1994
Brussels, Belgium

OF COURSE I WAS in love with her. She was a teacher. I did not mind that she gave me pet names. I found that rather sweet. But when she started to offer me children's books with hand-written dedications, it began to dawn on me that that sort of relationship could not last.

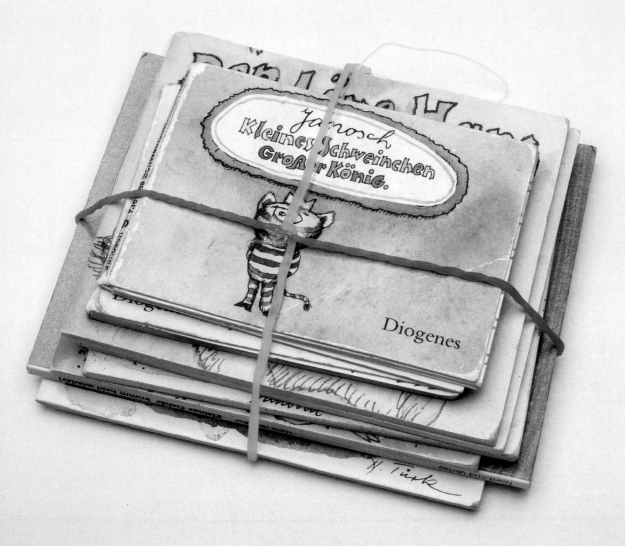

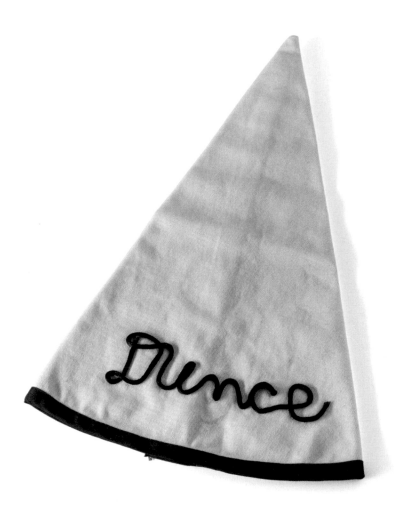

Dunce cap

2008 to 2010
Huntington Beach, California, United States

I MADE THIS for my ex-fiancé, a naughty boy who liked to play teacher and student. If he got too many questions wrong, he had to stand in the corner wearing this.

We didn't belong together, but I still miss him sometimes.

Olinka Vištica and Dražen Grubišić

The Tingler

2005
Zagreb, Croatia

THE TINGLER, an erotic head massager. One of the things one does not give back to ex-girlfriends.

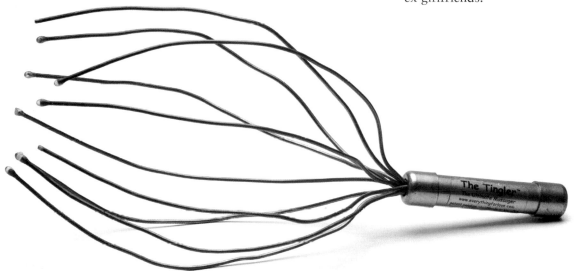

Pinocchio dick
(to wear on nose)

February 2010 to May 2015
Boise, Idaho, United States

I DATED A COMPLETE and utter narcissist on and off for five years. He abused me physically, mentally, and emotionally. Just months before he was arrested for assault, his buddy showed up at his shop one night (my ex is a metal forge artist/ blacksmith) with a surprise "gift." Nathan (my ex) had been whining about our failing relationship and how he just couldn't control his wild bursts of anger or alcoholism.

Steve listened as Nathan told him from a narcissist's standpoint just how much of a dick he had been. That night at the shop, Steve gifted him a hand-carved Pinocchio dick ... as Steve put it. "You can wear this every time you are a dick, Nathan." He went on to tell Nathan (right in front of both of us) to remember also to tell me three things every time he screwed up: "You're right. I'm sorry. I love you."

I have no idea how it ended up in the bottom of a box of art supplies, but I recently discovered it.

(P.S. I also ended up with the dog, and while she would be happy to hang out in an art museum for months, I refuse to let her out of my sight for more than a few hours.)

Olinka Vištica and Dražen Grubišić

Cat collar and tag

2½ years
Singapore

A CAT COLLAR I used to wear
as a choker. I engraved my
ex-boyfriend's phone number on
the tag to symbolize submission
to his ownership. I loved cats;
my loved ones always refer to
me as a cat.

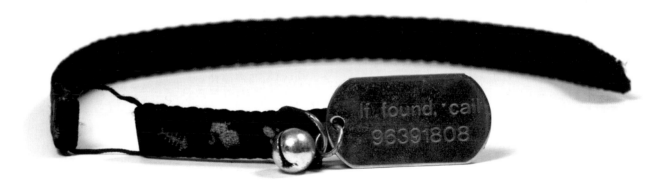

Magnetic chessboard

June 2008 to October 2014
Tallinn, Estonia

Made in China

Bought in London

Traveled to four corners of the world

Left to oblivion in France

Abandoned in Belgium

Check and mate! Instance in which the king is in the position of an inescapable check thus marking the end of the match.

Unopened candy G-string

2004 to 2008
Winterthur, Switzerland

THIS WAS WHAT he thought of as "romantic": a thong made of candy. I laughed, but never took it out of the box. He never bought me flowers because flowers, he said, were for boring people. Instead I got sausages or new parts for my bicycle. I didn't mind because I loved him. After four years he turned out to be as cheap and shabby as his presents. He cheated on me with a colleague from the office and dumped me via e-mail.

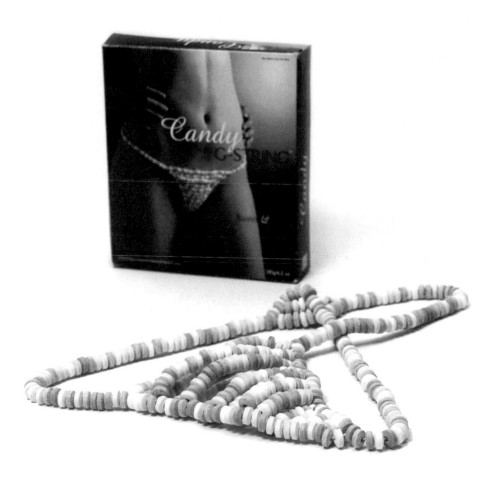

Mutually loved Davida font

October 2008 to December 2012
Los Angeles, California, United States

SHE AND I MET in a graphic-design class, and for her first project she used the silliest, most poorly used, and—to me now—most endearing font: Davida. She used it in the headline of a poster for a "Seventies Horse Derby." She thought the font was "groovy." I politely disagreed (we were just getting to know each other). About a week later, on an urban photo safari, we saw the same font used as the logo for an Indian rug store in Pasadena. To her it said "groovy"; to them, it said "Indian rugs wholesale." I laughed. She laughed. "Our font" was cemented.

As our relationship deepened, we collected about two hundred sightings of Davida, and discovered that its hard-to-pin-down personality has confused thousands of small-business owners and aspiring graphic designers all over the world. Yes, the world. Sightings included a café in Paris, a pizza parlor in San Diego, a book on elephants at a Hindu temple, a half dozen LA Mexican restaurants, a barbershop in Santa Monica, a Thai restaurant in Hollywood, a dry cleaner in New York City, a hot sauce brand from Florida, a very graphic "human anatomy coloring book," a brand of incense, a carnival in a Verizon ad. Once we were looking for it and once it became a game in our relationship, we saw Davida *everywhere.*

Of course, once we broke up, I still saw Davida everywhere, and I still do. I know all of the streets in LA where I could pass a Davida sign if I wanted to. I know when to look out the left side of the car if I want to avoid it. I never stopped collecting them. Partly in hope that maybe someday we'd get back together. Partly out of fascination about a font whose nature can be so confusing, yet so unifying … like love.

Red trainers

July 2006 to December 2009
Lincoln, United Kingdom

HE BOUGHT ME THESE trainers,
and they're beautiful like him.
They didn't fit and ended up
causing me a lot of pain and
discomfort, so I only wore them
for a short time. Like him.

White dress shoes

Unspecified time
Bloomington, Indiana, United States

SHE TRIED TO IMPOSE her fashion sensibilities on
me. I hate white dress shoes. They're part of a culture
that will forever be alien to me. I am just glad that
I don't have to occasionally wear them to keep her
happy anymore.

Paper Flowers

THE FIRST NIGHT we talked on the phone, it lasted until 3 a.m. I had driven to a local dive to play pool. I never made it inside, just sat in the car talking to you. "You're wonderful," you said after the bar was long closed. I was thinking the same about you.

Later I read you poetry. Berryman and Oliver and Cummings. Poems I had written before. Poems I had written for you. Sometimes you'd disappear for weeks at a time. Then a text would arrive, "I'm alone in a room. It's dark, and I am thinking of you." We had sex for the first time that night. Nothing before or after has ever been like it. Except, of course, all the other times with you. Sometimes you'd disappear midsentence. My calls back hitting voice mail after voice mail. Your greeting didn't even have your voice. It didn't even say your name.

We went on like this. You never wanting to meet. Me convinced you were everything. You were everything. Or at least you were most things, and I made you the rest.

Finally, I couldn't handle the disappearing any longer. I decided to show up at the museum where you worked. Flowers in hand—no, no, not flowers; those don't last. Paper flowers then. Yes. Paper flowers on pens, so they don't just look nice, they have a purpose, too. But not just any paper. Each was a poem we had shared. Around each stem a note just for you.

I arrived at the museum. Prepared to sweep you off your feet. Or to be rejected handily. Either way I would know for sure. As people we can deal with anything, as long as we know what we are dealing with.

They had never heard of you. No one recognized your photo. I tried every possible combination of your first, middle, and last name.

I called you.

"I'm just leaving work," you said.

"Where?" I asked. "Because I'm here."

You hung up the phone.

Olinka Vištica and Dražen Grubišić

Mobile phone

July 12, 2003, to April 14, 2004
Zagreb, Croatia

IT WAS THREE HUNDRED days
too long. He gave me his mobile
phone so I couldn't call him
anymore.

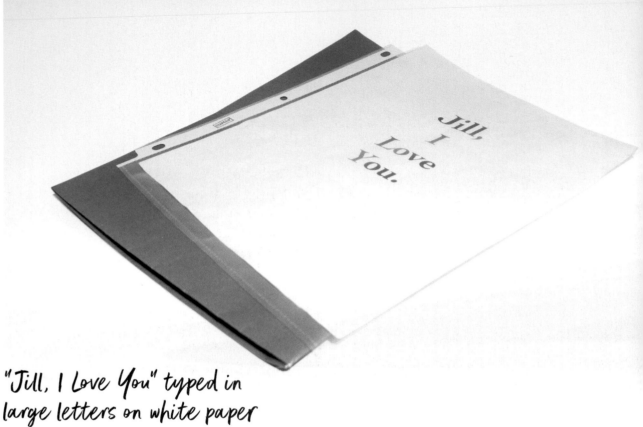

"Jill, I Love You" typed in large letters on white paper

April 2004 to November 2013
New York, New York, United States

MET WHEN I was married. Dated for nine years. He was bipolar and a struggling actor. Six months after we met, he had a manic episode. I left New York City to go to Greece where he had been placed in a mental institution. I went through recovery with him for the next six months, got him on the proper "cocktail," and he has been well ever since.

I supported us for the next seven years while he sporadically went on auditions and had odd jobs that barely paid to put gas in the car I bought for him. I eventually forced him to get a job waiting tables, which got him out of the house and gave him more confidence and money in the bank to help pay the bills.

He and a successful director created a show about themselves and their relationships. They sold the show, which he would come to star in, as well. At that point, I asked for some extra support so that I could pursue an opportunity to do what I really wanted to do. He was apprehensive, and I was angry. Didn't speak for three days, and then he came home to say he was moving out. He abandoned me and our two nine- and ten-year-old dogs, left us with no money and no roof over our heads.

His last words to me were, "There just isn't enough room in this relationship for two people to be chasing something speculative."

Broken Hello Kitty key

March 2013 to December 2016
Bakersfield, California, United States

WE MET at the dive bar in town right after
I turned twenty-one. He was fifteen years older.
I moved in with him after six months of dating.
Even though I paid the bills, he would always say
it was his house. During our last fight he went
into my purse, got my keys, and broke my house
key in half, effectively ensuring I couldn't get back
in unless he let me.

That day I began planning my move and how
to leave him. The key became "the key that opens
no door, but opens my freedom."

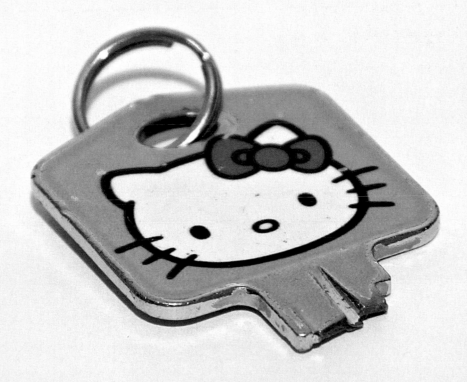

White underwear with embroidered flowers

January to February 2004
Philadelphia, Pennsylvania,
United States

I HAD BROKEN UP with my middle school boyfriend because he pressured me to have sex and started seeing another girl when I wouldn't. I was only fourteen and heartbroken about it when I met Y. He was eighteen and handsome. He kissed me passionately in an arcade the day we met. I couldn't believe he chose me.

A few days later, determined not to make the same mistake as before, I lost my virginity to him during Super Bowl Sunday. I was wearing these underwear and remember him commenting that he was turned on by how virginal and innocent I looked.

It all crashed and burned as quickly as it began—I found out he had a girlfriend who was pregnant. A few weeks later, I tested positive for chlamydia during a high school assembly about STDs. I cried on the school nurse's shoulder for two hours and never told anyone else. I've kept these hidden in my underwear drawer all these years as a reminder of why I am so cynical.

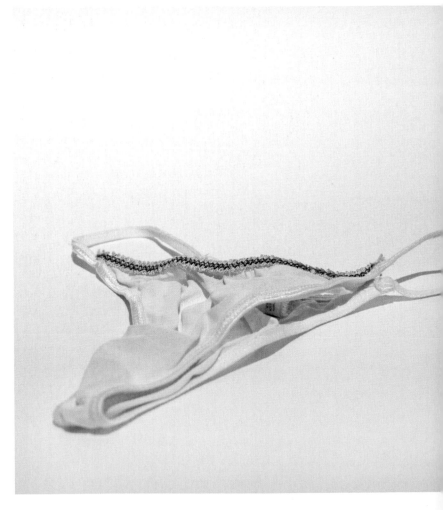

Olinka Vištica and Dražen Grubišić

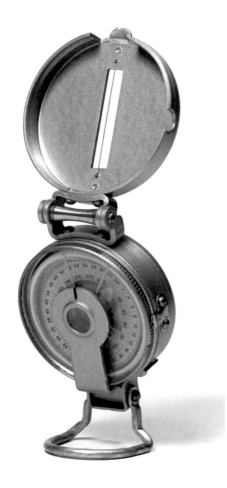

Lensatic compass

October 2010 to February 2011
London, United Kingdom

A BRIEF BUT intense affair. Was promised the world, and toward that was given this compass for Christmas to help keep to our shared path. Jumped in with everything, only to be left suddenly and unceremoniously one Saturday morning with the words "I can't do this." Have not heard a peep out of him since.

The gift was a romantic gesture, whose meaning changes dramatically and ironically in hindsight, as if he thought I might be needing it. I don't.

Statuette

2001 to 2010
Chatte, France

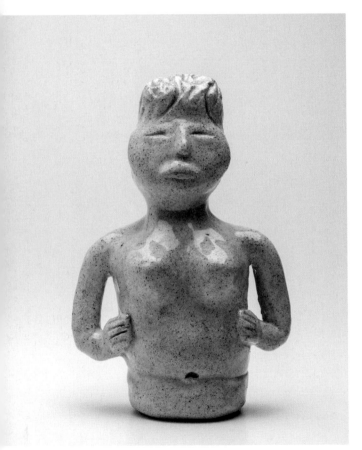

AFTER NINE YEARS of powerful love, my relationship with my girlfriend ended.

On my next birthday, she gave me a little terracotta statue that she had made, representing a woman who's waiting. She asked me to send her a picture of the place that I chose to put the statuette, but I never contacted her again. I spent two years after the breakup on a very small and isolated island near Antarctica for a scientific job. I tried hard to find a cave where I could leave the statuette in a place where nobody would ever find it, but I went back to pick it up every time. It was too hard to keep it with me, and even harder to leave it somewhere, forgotten. So the statuette came home, and I hid it in a secret place in my house. But that is not what I want for this object.

I will be proud and relieved if everybody can see this statuette and her story.

And also, I can finally send a nice picture to her creator.

Olinka Vištica and Dražen Grubišić

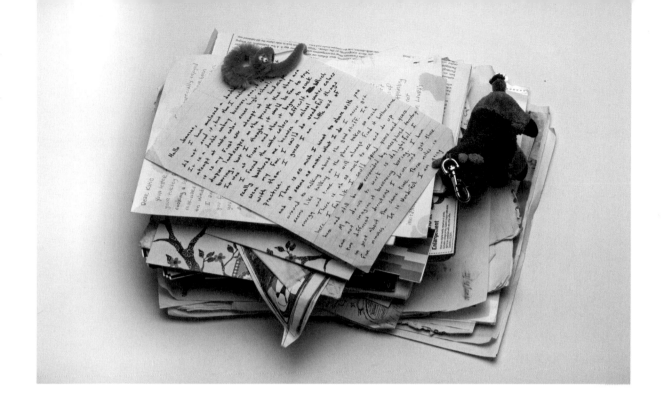

Box of letters and memorabilia

May 2006 to March 2012
South Pasadena, California, United States

WE BOTH LOVED the story of our meeting—on a train from Los Angeles to San Diego, packed full, standing room only. There was flirting and banter, and when we got off at the same stop, she offered me a ride.

There was no lack of love, nor of chemistry. But after a beautiful honeymoon period, we moved into volatility, battling alcoholism and codependency through intense fights and impossible promises.

We lived separately, together, long distance, and shorter distance, but never quite made it back to the same city together after our initial split.

This box of letters was collected mostly by her. During a borderline-violent fight when she demanded to have the letters, I threw the pile in the bathtub and started running water on them. She turned gentle and sad, and tried to salvage them.

I did indeed end up with the letters but no longer have room for their weight, and so I send them off to you.

Concrete with initials

7 years
Pittsburgh, Pennsylvania, United States

THERE ARE NOT WORDS for what we were, as there are rarely words for such things. We assumed titles throughout our time together: friends, lovers, coworkers, husband, wife. But none of them fit now. They never fit. He was who he was. And I was who I was. And for a time we were who we were.

In that time, we repaired the sidewalk outside of the building where the two of us worked. It was in terrible disrepair, a liability really. A year later, when we were no longer a couple, crews came in and replaced the sidewalk altogether.

I tried to save this piece of it, the piece that held our initials: AC + AK. But his were lost.

That's the thing about initials in concrete: they're really just an idea of a thing. The slightest disruption and they're lost.

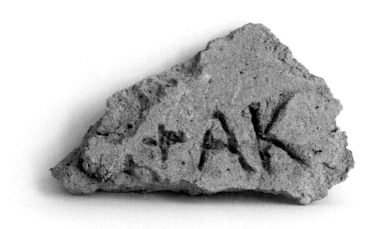

Olinka Vištica and Dražen Grubišić

Rock

11½ years

Boise, Idaho, United States

AFTER MY FIRST miscarriage, I felt the need to bury the remains somewhere in the woods as a matter of closure. I hiked Bogus Basin by myself for four hours trying to find the spot. I was out until after dark. I never found it, and later buried everything at White Bird pass, but I kept this rock as a reminder. It was a reminder of my codependence and how isolated I felt in the healing process.

My steps to feel better are still taken alone, since he shut off after the first, and almost disappeared after the second.

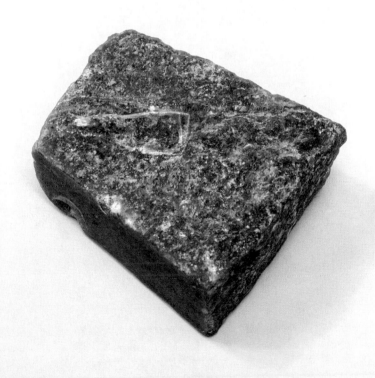

Size 3 stainless steel wire ring with pink bead

2001 to 2016
Fairfax, California, United States

I WAS SEVENTEEN years old. I chose the color, and together we watched the vendor curl the wires as my boyfriend's lips formed the promise. Other rings followed, but this humble ring purchased off the street was the most honest. He had nothing then, and yet he feverishly promised me everything. I moved across the ocean (twice), bore him children (twice) to give him his everything, but apparently that wasn't enough.

On New Year's Eve, fifteen years later, my voice shook when I asked him if he took off his wedding ring when he visited prostitutes. He snorted as he told me that they didn't care. At Narita Airport, San Francisco–bound, I took off my wedding rings and zipped them into my purse. Now, as I unpack this little pink ring from a box postmarked Tokyo, I want nothing more than to scream full force and throw it into the Pacific Ocean.

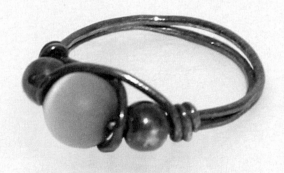

Olinka Vištica and Dražen Grubišić

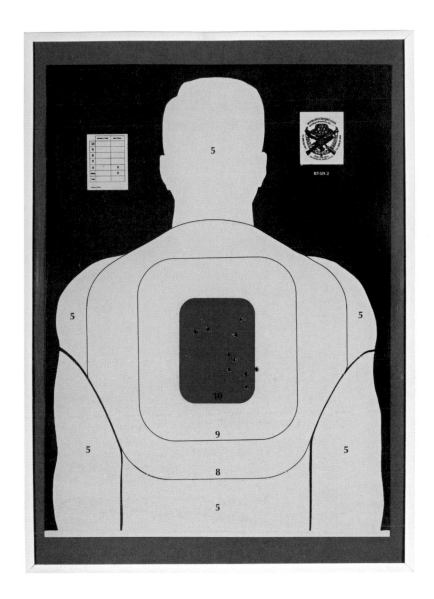

Target

November 1, 2011, to October 21, 2015
Copenhagen, Denmark

A TARGET that my ex shot at with an AK-47 when we were together at a shooting range in Los Angeles.

Butcher knife

23 years
Boise, Idaho, United States

YOU HAD ASSUMED the role of the Cook, but occasionally let me use the kitchen, too. You said I didn't know how to take care of knives, so you said I needed to stop using your special, sentimental chef's knife. You took me to a knife store and bought me this one— my remedial knife.

Funny, how you then got to use my knife and yours, too. Also funny that you had designated yourself the Knife Sharpener, and our knives were infamous in my family for being the dullest ever. Couldn't even cut a tomato or a mushroom. No wonder I stopped cooking then.

I have my own set of knives now. And they're shiny and sharp. And I cook just fine.

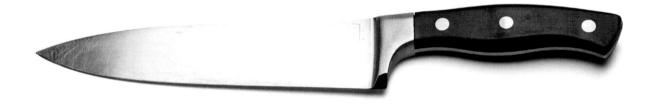

Olinka Vištica and Dražen Grubišić

Lady Lamp

July 2010 to September 2012
Whitehorse, Yukon, Canada

WE PACKED EVERYTHING we could fit into a car and moved out East together for a few years. "Lady Lamp" didn't quite fit and was left in storage with a few other beloved items. She never really belonged to me, but I ended up with her by default: I was the only one who returned.

Brazilian Playboy collection

August 2010 to October 2012
São Paulo, Brazil

SEVERAL MONTHS into our relationship, we decided that we should live together. After the torture of finding an apartment in São Paulo, we finally found a place and moved in together.

And we were happy, for a while. I loved being with him, and I loved being a couple. But within a few months he started to distance himself from me. When we decided to break up, he didn't have another place to stay, so we agreed to continue sharing the apartment, even though we were no longer lovers. Although it was painful living so close (and yet so far), it was my way of slowly cutting the ties.

However, being too nice for my own good, when he did finally move out, I let him store his collection of *Playboy* magazines in a closet. I never had any problems with the magazines themselves—though it baffles me why someone would pay for porn nowadays; Internet, man!—but now I want to clear the space. I asked him to pick them up and told him they would be recycled if he didn't.

Since he just missed his last deadline, here it is: the *Playboy* collection. It shows how silly a man can get over some nude pics.

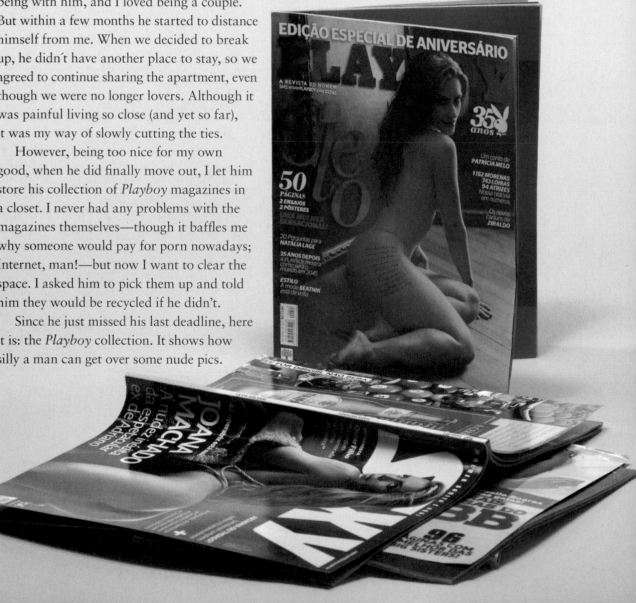

DUMPED! animated DVD

August 24, 1995, to November 16, 2009
Jersey City, New Jersey, United States

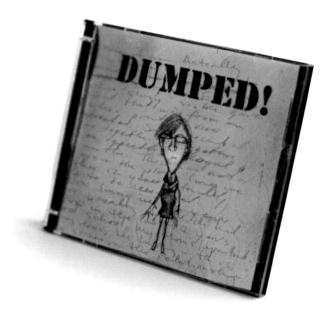

SHE AND I HAD been together for twelve years when the state of New Jersey decided to grant civil union status to gay and lesbian couples. We were the first (and, I believe, the only) people to take advantage of the opportunity in the town in which we lived. We had a ceremony to celebrate. There was not a dry eye in the place. We were proud to finally be able to stand up and be counted. Another victory for civil rights!

The last year of our relationship she began watching *Guiding Light*, a TV soap opera. It was on the brink of being canceled, so they decided to run a lesbian story line, known as Otalia, which drew a fan base of approximately five thousand lesbians throughout the world. Fans threw parties, formed clubs, and would get together on a regular basis. They stayed in constant touch on Twitter.

My ex, who has a tendency to get manically involved with things, went full force into the Otalia phenomenon. Needless to say it put a strain on the relationship. Eventually, she tweeted herself into another relationship with a fellow fan, and left me without warning.

To add insult to injury, my mother was in the last stages of her life, and I was left to deal with the situation by myself. Since we were legally bound, we had to get a divorce, which resulted in selling the house. *DUMPED!* depicts the time when I was trying to wrap my head around the fact that my partner of fourteen years was leaving me for a soap opera.

Jar of spicy Amish pickles

October to December 2013
New York, New York, United States

I BOUGHT THESE as a present for the first guy
I ever (thought I) loved. He told me about how he
used to do his homework in the bathtub as a kid
and brought me a book on our first date, and
said he loved these damn pickles. He stopped
returning my texts before I ever got a chance to
give them to him.

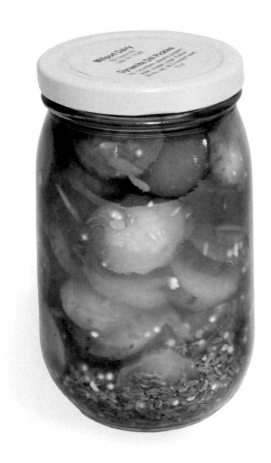

Olinka Vištica and Dražen Grubišić

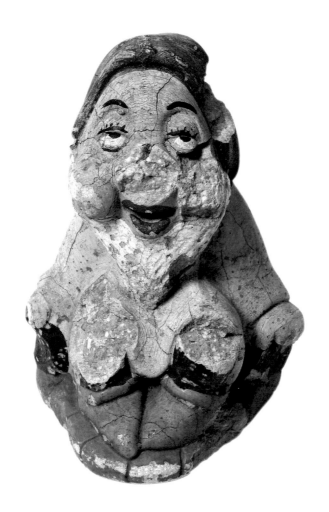

Divorce day mad dwarf

20 years
Ljubljana, Slovenia

HE ARRIVED in a new car on the day of our divorce. Arrogant and heartless. The dwarf flew into the windshield of the new car, rebounded, and landed on the asphalt surface. It was a long loop, drawing an arc of time—and this short long arc defined the end of love.

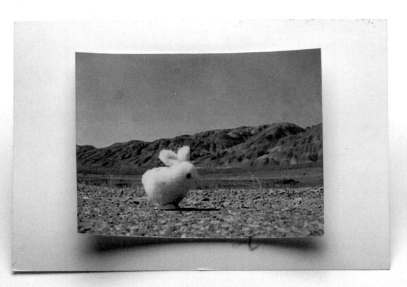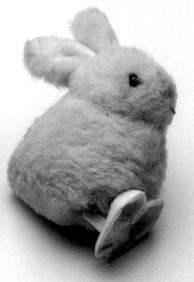

Honey bunny

1999 to 2003
Zagreb, Croatia

THE BUNNY WAS supposed to travel the world
but never got farther than Iran. This is not
Photoshopped but a real photo of the bunny in
a desert near Tehran.

Olinka Vištica and Dražen Grubišić

Comfort doll aka voodoo doll

3 months
San Francisco, California, United States

AFTER A HARD BREAKUP, Alexander started collecting articles of clothing from lovers and one-night stands. In dealing with past abandonment issues the artist creates comfort dolls to ensure that even though the intimacy between him and the lover is brief, he will always have the lover in his possession in some form. This is also reminiscent of his days when he would play with his action figures and was in full control of their actions.

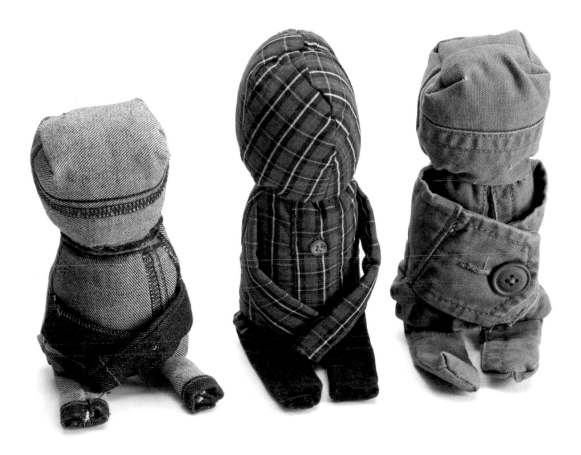

The space in between

Summer 2009 to winter 2012
Belgrade, Serbia

WHEN YOU WAKE UP from a dream the details in
pictures are missing, but the emotions are so strong,
you can feel them even in your toes, in your bones,
in your ears. As in a dream, the sky was spotless,
the beach was empty for as far as you could see.
We were wrestling on the inflatable pool raft, I was
jokingly telling her I would sell her to a gang of
human traffickers, and she was haggling for the price.

 We both let go of control and surrendered to each
other. She was shamelessly her quirky self; I was
shamelessly my quirky self, and in between there
was love.

 Shot in Ada Bojana, on the Montenegrin coast.

Olinka Vištica and Dražen Grubišić

Carpenter's tool

April to July 2009
Brussels, Belgium

WHEN JEAN MARRIED PAULE, his boss's daughter, he inherited many of the boss's tools, including this weirdly shaped thing. Although Jean was good at DIY and used most of the tools, he never used this one because he didn't know what to do with it.

Paule was my mom, and Jean my dad. When they passed away, the undertaker spent several days helping me sort everything out in my parents' house, including the basement, where my dad kept all these inherited tools.

Then the undertaker began calling me every evening to check if I was okay, bringing fresh eggs, inviting me to his place, and so on—not part of the usual service expected from a funeral director. But, you see, my dad thought I would be unable to take care of the house when he died, and he asked his friend, the undertaker, to watch over me.

Which he did. He still does. But despite being a carpenter in addition to being a funeral director, he doesn't know what this tool is for.

Crossword puzzle

Since the beginning of my life to April 14, 2015
Bologna, Italy

MY FATHER DIED on April 14, 2015. I was with
him at the hospital, caring for him. He always
played these crossword puzzles. The last one is not
finished. He was fun, enigmatic, and comforting.
Just like a crossword puzzle.

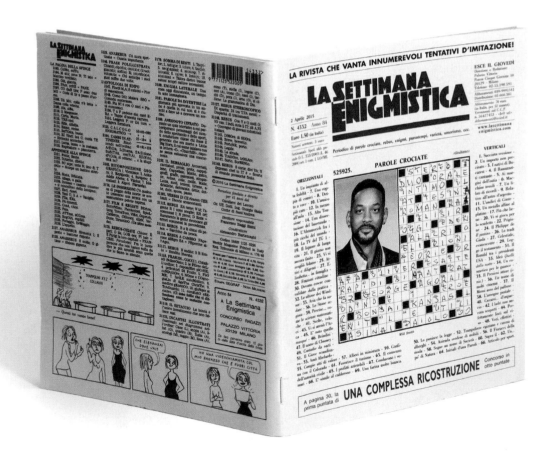

Olinka Vištica and Dražen Grubišić

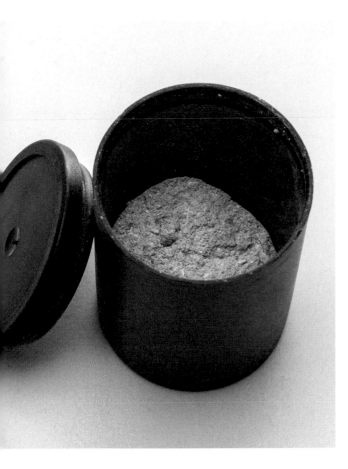

Film canister with small amount of ashes

May 1979 to July 2012
Tallahassee, Florida, United States

WE MET TWO YEARS after he was widowed at nineteen, a single father with a baby to raise. Together we made a brother for his little boy, and we became a family of four.

It took him ten difficult years to heal the wounds. He had been behind the wheel, and the guilt and loss were overwhelming. No self-respecting woman would have endured his self-destructiveness, but I couldn't leave. Grace saved us; time and love healed us. Life became blessedly normal.

We were married for thirty-three years, growing up together, looking forward to being old together. The cancer took him in four months. He died a splendid man, a loving inspiration to all who knew him.

He said, "Live a life of love." He said, "When I die, give my ashes away in film canisters. Have my friends blow them to all ends of the earth."

I am in my fifth month of traveling around the world. I have sent him over Victoria Falls, into the Caribbean, Adriatic, and Mediterranean Seas and the Indian and Atlantic Oceans, buried him in an elephant-protection wall in the Namibian desert, cast him off the Cape of Good Hope, hid him in a Capuchin crypt in Rome, blew him over a Croatian cemetery on All Saints Day, tossed him into the Plitvice Lakes …

> Your Ashes, the Host
> You left me in summer with instructions
> to feed you to the world.
>
> Your ashes are bitter
> on my tongue, but sweet in the language
> of earth.

New Yorker

2007 to 2012
Cambridge, United Kingdom

SHE WROTE an advertisement for a think tank: "Wanted: thinking people." I felt someone was calling me. During the opening lecture she was the only one who dared to ask a question. I looked at her; she turned around and saw me looking. Her smile was cute and mischievous, with a gray tooth. We were too clever to be fooled by small talk.

On our first date she entered my tiny house with a pink sweater and mud on her boots. "So what should I do?" she asked. Sarcastically, I suggested she clean them on my new silk carpet, so she did, without a second thought. That was her, never apologetic, with lots of energy and wit. We did not leave the house for three days.

I think the entire city knew her. She did everything from establishing an NGO to editing a magazine. She knew prime ministers and ministers. A few months after we met, she joined a major news corporation as a desk helper—soon afterward she was leading their team as a chief producer. She was covering a war while I was fighting it.

I got an offer from a university abroad, and she agreed to join me. When we left the country, she cried a lot. It was like seeing a newborn leaving its mother's womb. She looked lost, and it was only me.

She introduced me to the world. In New York she showed me the museums, the restaurants, and the *New Yorker*. I, on the other hand, taught her how to hug—but it was like catching a flame, you can only pretend it is yours.

I'm reading the *New Yorker* now. The thought that somewhere in Delhi, Nairobi, or London we share one more incredible piece of information makes me smile.

This is the last issue we shared.

A handmade full Monopoly set for our twentieth wedding anniversary

February 1987 to June 2013
Rugby, United Kingdom

FOR OUR TWENTIETH wedding anniversary I made a full-sized Monopoly set by hand. It took weeks of toil. Every property meant something in our lives and relationship. All the Chance and Community Chest cards told a witty comment about us, a nod to those in-jokes we had. Eighteen months later it was over; she told me she didn't love me anymore and I could keep the Monopoly Set. We only ever played with it once—I lost.

With that I played my get out of jail free card, and I've been advancing past go ever since.

Empty wooden bottle of rum

July 2014 to June 2015
**Sherman Oaks, California,
United States**

WE STARTED DRINKING this rum in a hotel room in clear, nondescript glasses under crisp white sheets. Getting drunk, getting to know him, and getting happy. We finished the bottle a week later on my couch. We had ordered a tableful of Italian food. We were drunk, we were full, and, again, we were happy. By the time we had finished the bottle, we were in love.

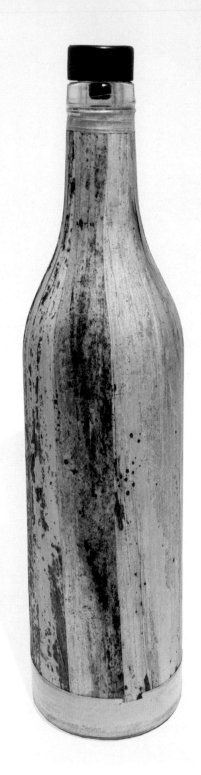

Olinka Vištica and Dražen Grubišić

The toaster of vindication

2006 to 2010
Denver, Colorado, United States

WHEN I MOVED OUT, and across the country,
I took the toaster. That'll show you.
How are you going to toast anything now?

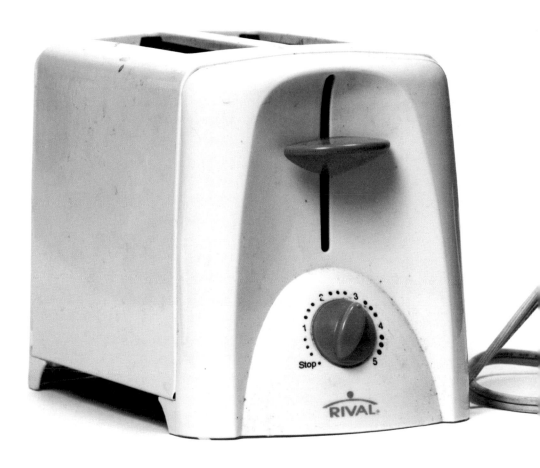

Belly button lint

November 2013 to April 2015
Montreal, Quebec, Canada

D.'S STOMACH HAD a particular arrangement
of body hair that made his belly button prone to
collecting lint. Occasionally, he'd extract a piece
and stick it to my body, which was sweaty after
sex. One day, angry he'd disrupted the heavy
charge that lingered in the wake of an orgasm,
I met his oddity with my own: I put the lint in a
small baggie and concealed it away in the drawer
of my bedside table.

Our relationship was tumultuous; as off-again
as it was ever on. From time to time, he would
remind me that he wasn't really in love, but
I blithely ignored the warning. He gave me his
lint, after all.

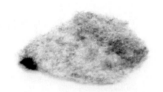

Olinka Vištica and Dražen Grubišić

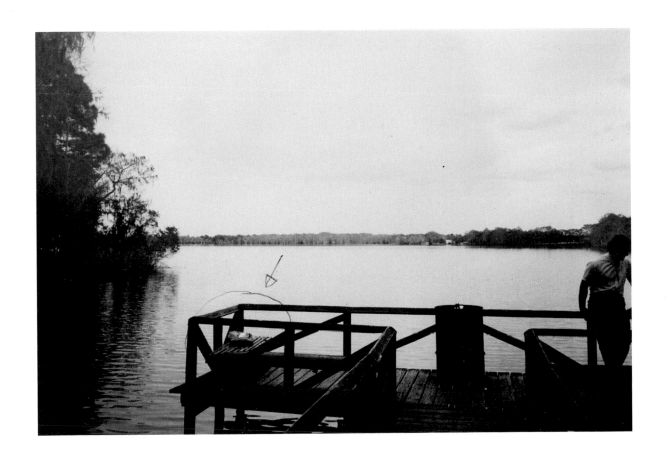

Photograph

1993 to 1995
Bloomington, Indiana, United States

A FLORIDA LAKE where I skipped school with
my boyfriend. The arrow indicates the spot where
I first saw a penis in the sunshine.

Book, The Sorrows of Young Werther

1986
Amsterdam, the Netherlands

MY FIRST REAL LOVE involved the most popular boy in my class. I was almost too afraid to talk to him—let alone look him in the eye. In our German classes in secondary school we used to sit next to each other. He already had a girlfriend; the girl with the largest breasts in the school.

We both chose the book *Die Leiden des jungen Werthers* to read for school. The school library had only a few copies, however, so we decided to share. I read the book and Goethe convinced me to out my love to R. I scratched a secret message in the first chapter by underlining letters in red. Would he think of connecting the letters?

The message was something like: "I am in love with you, R. If you feel the same way, meet me at the small lake in the woods on January 13. I'll be waiting." At the lake I waited and waited until I heard a moped approaching. The feeling was mutual.

During a bar fight a few months later R. was being beaten up. I jumped in and joined the fight. While I was in bed for two months, recovering from my injuries, he took off with my best friend. I reread *Die Leiden des jungen Werthers* in tears. I finally understood the concept of romantic love and renounced it forever.

Olinka Vištica and Dražen Grubišić

Galileo thermometer

Fiery 6 months + heartbreaking 4 months
= 10 months
Taichung, Taiwan

A TEENAGE CRUSH on campus. Now I am writing it all down in remembrance of the pure love.

At the time, I had an almost feverish imagination about what kind of a boy I would fall in love with, and I even listed all the criteria. He should:

1. Be tall
2. Be tanned
3. Play music
4. Love post-rock
5. Especially love Explosions in the Sky
6. Be able to cook (hopefully)

And I met him! He satisfied all my criteria; he could even cook! As luck would have it, this boy, my Prince Charming, also fell in love with me. We started our whirlwind romance. Like any girl in love, I felt like the luckiest girl in the world. This passionate love lasted about six months. One day I realized that a criteria-fulfilling boy might not necessarily be a considerate and tolerant lover. He might not understand you. For my twentieth birthday, he gave me this Galileo thermometer, wrapped in a crushed paper box—as my birthday gift?!? We broke up.

From that day on I have never made another list.

Moroccan cedar pen case

September 2014 to July 2015
Arlington, Virginia, United States

THIS WAS THE LAST gift he gave me.

He went to Morocco to visit his mother the week after he broke up with me. I was working at the bar on a brunch shift when he came in. I was wearing a black velvet T-shirt and bright red lipstick. I stepped out from behind the bar to greet him, I felt my face flush hot. He looked saturnine, as always. He kissed both of my cheeks, greeting me in his distinguished Moroccan manner. It felt intimately distant. He opened the brown paper grocery bag he was carrying so that I could see the bowl he was certain belonged to me. It didn't. I took it back anyway. And then he said, "I got this for you in Morocco." I reached into the bag and pulled out this little wooden pen case. He was always telling me to write, ordering me to *just write*. And then I would be happy. He wanted to be the champion of my unborn art. A patron saint: emblazoned in my memory as the one who made me write again.

I held the case in my hand; the cedar was smooth. Then work got busy and I had drinks to make. I don't remember if I thanked him: I was nonplussed. I thought about running after him, and saying thank you, or I hate you. I was ready to cry. But when I opened the case it was empty. The final token of his affection.

He wanted to get the last word. I brought the case home and found my favorite neon LAMY fountain pen on my desk. I unclasped the wooden case and set the neon yellow pen inside. It didn't fit.

Olinka Vištica and Dražen Grubišić

Small suitcase

October 10, 2004, to April 19, 2007
Belgrade, Serbia

TWO AND A HALF years packed up
in a small suitcase … I always knew
a small suitcase would suffice.

Rubber gloves

4 years
Seoul, Korea

AS SOON AS I got married, I went to live abroad. Then when I came back to Korea, we moved in with my in-laws, for financial reasons and because we had to move unexpectedly. From the very first day I became a prisoner to household chores. If I made breakfast, lunch, and dinner for my mother- and father-in-law, I would end up spending the whole day in the kitchen. If I went out to meet my friends, I felt uncomfortable and guilty, so I would return home early. My own life gradually disappeared, and I felt like a machine designated to do only housework. Now that we are finally moving out of my in-laws' home, I am donating the last pair of rubber gloves that I used there as a symbol of my household labors.

I think I can finally live a life of my own.

Olinka Vištica and Dražen Grubišić

Danger spoon

December to July 2015
Los Angeles, California, United States

ON THE NIGHT we met, he told me his nickname was Danger. Since he loved to cook with a wooden spoon, I bought him this custom, left-handed spoon that says "Danger Est. 1.7.1987" (his birthday). He cheated and left long before it was finished and shipped to me. Never used. Still dangerous.

Broken Donovan single

23 years
Brussels, Belgium

THIS BROKEN Donovan single symbolizes the
sudden breakup with the man in my life. After
twenty-three years, he left me overnight for
someone else, taking with him his entire collection
of almost two thousand records. I asked to be
allowed to keep just one, but he refused on the
pretext that "You never listen to records anyway."
Following his betrayal, this mean and selfish
response was the unkindest cut and, just before
the removal van arrived, I took hold of the
Donovan single "Colours"—which ends with the
words "without thinkin' of the time, of the time
when I've been loved"—and smashed it.

Olinka Vištica and Dražen Grubišić

Pandora's box

6 months
Southport, United Kingdom

IT IS SAID that Pandora (the first woman in Greek mythology) possessed a box… Her box contained all the evils of the world. Unlike my box, which has only a pair of Ann Summer's pants. But these pants are no less evil, I promise you! When Pandora opened her box, all its evils were released into the world; the evil I let out was trying to have a reasonable relationship with an unreasonable woman. In Pandora's story the remaining item in her box was Hope. Opening this box I'm glad to see no hope for us; I see only Pandora's pants, and I do not want to see them again.

Wedding rings

7 years
Bergisch Gladbach, Germany

THE RINGS ARE from our civil ceremony. The inner golden wave symbolized the flow of life and the act of allowing each other space. Both rings were engraved with the words "LOVE STRENGH COURAGE," things that we both urgently needed.

It was 1998 and I was a single mom. My two sons and I had moved into a small house, where for the first time we could actually afford a TV. Being clueless about the necessary technology, I went into the local electronics shop and asked for help from one of the staff members, a very pleasant man whom I had met several times before. He offered to come by after hours. Happy that my boys would soon be able to watch television, I opened the door in the best of moods when he came over. We drank wine and laughed a lot, and it was quite late when he finally started tuning the stations. Knowing next to nothing about technology, I believed him when he said that it would be a very lengthy process. Hours later I had

fallen asleep on the sofa and he in front of it. From then on we were a couple. We often laughed about the fact that there is an Auto Tune feature that configures the stations by itself, but since he had fallen in love with me immediately, he had needed an excuse to spend time with me.

After many happy months together I fell seriously ill, so ill that the doctors gave up on me. At the time of our wedding, I could barely stand on my own. I spent the first two years of our marriage lying down, and we had to call the ambulance on several occasions. It was a difficult time. Then my husband found a doctor who believed there was a minute chance of recovery, and I underwent a painful therapy. So that I wouldn't have to stay in the hospital, my husband took it upon himself to give me the necessary six hundred injections. Eventually the miracle happened! Slowly, I started recapturing life. We both cried with every bit of progress my body made, envisioning a wonderful future ahead.

Finally, the day came when I was able to dress myself, and I jubilantly ran downstairs singing a happy song. That same day I found his farewell letter on the kitchen table.

Myriad questions remain unanswered to this day.

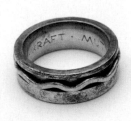
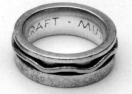

Olinka Vištica and Dražen Grubišić

Transplant caretaker manual

February 2015 to February 2016
Akron, Ohio, United States

MY BEST FRIEND had cystic fibrosis. We dated
for almost a year, for half of which he was on
the waiting list for a double lung transplant. He
received his new lungs on January 20, 2015. He
ended our relationship two weeks later. I'm so
happy for his new chance at life. I'm very sad
that I won't be part of it.

Very old red racing bike

16 years
Etterbeek, Belgium

He left it there … for me, That rickety road racer.

He had bought himself a new bike,

And there was no room in his "new life" for the old one …

I looked it over, Tried it out,

Bought special clipless shoes

And raced it round Pajottenland to chase away the blues

Last week I bought a new one, thinking what the heck,

A carefree singleton like me has no use for that old wreck…

Danielle, sixty-three years old

Olinka Vištica and Dražen Grubišić

"Mejor Sola Que Mal Acompañada" tile

August 29, 1987, to December 4, 2004
Houston, Texas, United States

AFTER EIGHTEEN YEARS of marriage, my husband ran off with a twenty-six-year-old coworker. Shortly thereafter I went to Tijuana, Mexico, to have this tile made. It has served as a daily reminder that I am "better alone than in bad company." Since then I have raised my two sons on my own and obtained my master's degree in nonprofit leadership. I now share this artifact to inspire others facing a relationship loss to focus on claiming and expanding their own personal power.

Intimate shampoo

1995 to 1996
Split, Croatia

AFTER THE RELATIONSHIP ended, my mother used this for polishing glass. She claims it's absolutely great.

Olinka Vištica and Dražen Grubišić

Wedding veil

1978 to 1983; 1988 to 2012
Boise, Idaho, United States

AS A BRIDE of twenty, I took myself so seriously when I wore this in church the first time around. Young marriages often don't last long, and it didn't feel like a failure. My next, ironic wearing of it was thirty years later at a vow-renewal ceremony with my second husband, officiated by an Elvis impersonator. As we left the "chapel," my husband stepped all over it with his sparkly gold platform shoes. I flailed and cursed, head jerking backward. He was oblivious. I finally managed to yank the train out from under his size 12s. He couldn't see me, he couldn't feel me—it was a microcosm of our relationship. This marriage was longer, there were children, it didn't last, and it felt like a failure. Keep this bad-luck veil.

Slice of watermelon or ... ?

1986 to 2004
Skopje, Macedonia

Passion, passion, love, dreams, friendship, support,

Damyan, love, love, real life.

Real life, less passion, less love, less friendship,

Less us, more I and I.

Two parallel worlds, two parallel paths.

Watermelon or just an illusion? Or both?

Parallel lines do not meet.

I'm fortunate to have Damyan and to enjoy real watermelon in summer.

The illusion is gone.

Parallel lines do not meet.

Olinka Vištica and Dražen Grubišić

Transparent box with a stone collection inside

1992 to 1997
Heidelberg, Germany

GATHERED ON NUMEROUS romantic hikes on the coastline of the isle of Rügen, the Belemnoidea fossil, among other stones, represented my hope for an everlasting intercontinental love...

Texas license plate

2007 to 2010

Los Angeles, California, United States

I followed a boy to Texas.

TEXAS!

The middle of the country.

I have only ever lived by the ocean—

I detest that state, and the state it put me in.

Finally, one day I drove west on I-10 until I hit the sand again. I left.

With a license plate.

Olinka Vištica and Dražen Grubišić

1950s bag floor lamp, a little ragged and burned

5½ years

Basel, Switzerland, and Dortmund, Hamburg, Bochum, and Düsseldorf, Germany

A BEAUTIFUL BAG floor lamp from the 1950s, a present from my best friend. She bought it at the Basel Market Hall flea market. It came to me in Dortmund by train. I still lived there at that time. It turned into an important set-design item for my stage performances and even got a name, Gertrude. This floor lamp accompanied me everywhere, even on the stage. There are many photographs of me with Gertrude in the background, standing in parking lots, traveling by train to my performances. It was even the central object of an expensive photo-shoot in Düsseldorf— this floor lamp had its own stage personality. It even had its own diary: "And Thus Shines Gertrude—Diary of a Floor Lamp."

But it seems that my then-friend did not want to be overshadowed by it anymore. One day I found Gertrude in sex photos on the Internet. The copulating bodies had no heads, but my floor lamp was in the background, and I realized that the naked man was my then-boyfriend, with whom I had left the lamp for a couple of weeks.

Now the lamp and this past relationship really have their best days behind them.

Pay phone receiver

February 2014 to February 2015
**Grand Terrace, California,
United States**

I FELL IN LOVE with a junkie.
I found his insane antics charming.
One day, as a gift, he gave me a
phone with wires hanging from it.
It was a pay phone he had ripped
off in Echo Park the night before.
I was not there.

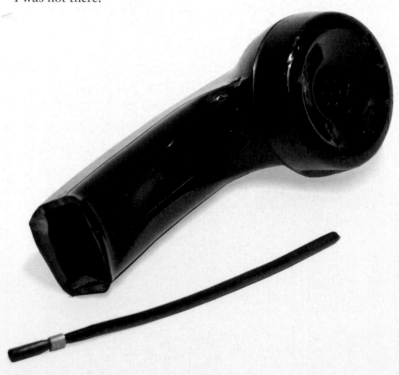

A side-view mirror

1983 to 1988
Zagreb, Croatia

ONE NIGHT his car was parked in front of the "wrong" house. He paid for that negligence with his side-view mirror. I was sorry afterward since the car was not to blame. The wipers also got their share, but they were made of more solid material and thus stayed on the car. The following day, when the "gentleman" came home, he told me a weird story about some hooligans who had torn off his side-view mirror and bent the wipers. It was so funny that I was tempted to confess. Still, since he never told me where he had been that evening, so neither did I. It was the beginning of the end of our relationship.

Two old picture postcards of silent-era film stars, torn to pieces

13 years
Helsinki, Finland

I WAS SITTING in a state of shock on the hall floor in my home. A moment earlier I had sent my husband a message asking him to return home immediately. I had come to realize, without a shadow of a doubt, that he had been cheating on me and lying to me for a long time. As I sat there on the floor and waited, I had the urge to break something that was his and chose a small plastic object, worthless in terms of money or sentiment, but nonetheless his. I got a pair of kitchen scissors and started to cut the object into small pieces. Before long, he walked in looking very angry, and then he saw me on the floor cutting up his worthless plastic toy. He could see from the way I looked at him that I knew.

When he saw what I was doing, he marched over to the mirror on my dressing table, where years ago I had attached two very old black-and-white picture postcards. I had bought them in a secondhand bookstore in Porvoo. They featured two American silent-film stars, Barbara La Marr and John Gilbert. I had chosen the cards because I found them beautiful, and later when looking up information on the actors online, I found out that they, too, had had a stormy relationship. My husband and I had often laughed at this coincidence, and he found the cards to be very beautiful as well. But now he ripped them into pieces before my eyes. That was how disappointed he was to be found out as a liar.

I had never lied to him.

Diamond ring

2010 to 2012
Arcadia, California, United States

S(HE) BE(LIE)VE(D).

Olinka Vištica and Dražen Grubišić

GPS

2004 to 2011

Tempe, Arizona, United States

BEFORE HE LEFT to join the Peace Corps, he bought me a car and gave me his GPS so I wouldn't get lost. He said this was his engagement ring to me. Since then the car has been totaled and is no longer mine. The GPS took me to the wrong location one too many times.

I recently found out he is getting married to his Peace Corps sweetheart.

Cross-training gloves

September 22, 2011, to October 30, 2013
Mexico City, Mexico

A YEAR AFTER we met, I began losing weight and started hanging out with a fitness group. First swimming, then lima-lama martial arts. My ex-boyfriend always supported my practicing these sports; he felt proud to have a strong girl. I started doing CrossFit, a military type training which at times uses bars, and, since I wasn´t used to it, I got calluses on my hands. We went to a sports shop, where he bought me these cross-training gloves so I could hold the bars. Since I did so much exercise, I started having more confidence and a better body. Fitness and sports took up a lot of my time. This sparked jealousy and insecurity in him.

One day at his house, he demanded to know if I had another relationship, or if I was seeing someone else. No, I said: he was the one that had cheated, to which he said yes. At first I cried, but when he began telling lies and making up excuses, I got up and hit him in the face. Once. Then again. The third time I hit him, his tooth came flying out.

I didn't know what to do. It was a huge adrenaline rush, but I started shaking and apologizing. We went to three hospitals looking for a dentist but couldn't find one. I called my dentist, and he recommended placing the tooth in its place so that the wound wouldn't close up … I have seen my ex-boyfriend twice since then. He had braces that held the tooth in place. I had promised to take care of the expenses, but my anger wouldn't let me. Also, my dentist said the tooth was in bad shape because he smoked too much. (My ex-boyfriend's aunt was a dentist, so I hope that the tooth turned out not to be very expensive.)

I just remember that that week in my CrossFit class I managed to do seven lifts with the bar. I had taken some really good boxing classes. Striking the blow did not make me feel better, though, and I'm sure I won´t do it again. I am not with him anymore, but now I'm able to do ten consecutive bar lifts and climb the rope.

Pepper spray

2014
Whitehorse, Yukon, Canada

PORKY GAVE ME this can of mace to protect me against the bad guys. It was thrilling to receive a weapon from the tool kit of a man who seemed so invincible. I couldn't cross borders with it, however. When I traveled out of the country and ended our relationship I became once again a vulnerable little girl.

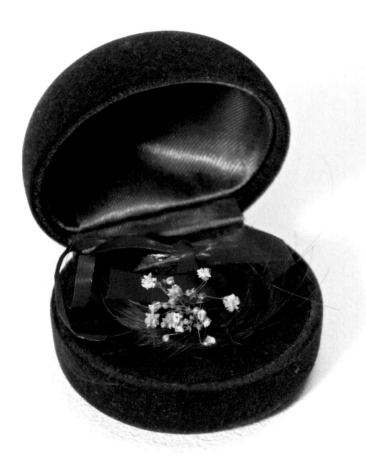

Wisp of hair

Less than 2 months
Skopje, Macedonia

A VERY SHORT relationship, but one that was psychologically so tough and crazy that it brought me to a moment of complete madness… And I cut my hair and lived without it for a long time; and no one loved me… And I was happy.

Lock of hair

June 1990 to October 1999
Mexico City, Mexico

WHEN I WAS TWENTY, I fell in love with Enrique, a wonderful man who was thirty-three years older than I. The story, our story, was a story of true love; the age difference didn't matter, and neither did the approval or disapproval of my family and friends. We loved each other very much and spent nine magnificent years together enjoying loads of happy moments.

The relationship ended due to natural causes. He died on October 2, 1999, two days before his sixty-second birthday. There has not been a single day since I met him, even after his death, that I have not thought about him. My heart is broken, but somehow I have managed to survive.

On the tenth anniversary of Enrique's death (2009) I cut my hair in mourning. I wish I could let Enrique rest in peace, and so today I'm giving you the hair I cut a few years ago, even though I have not been able to cut my love for Enrique.

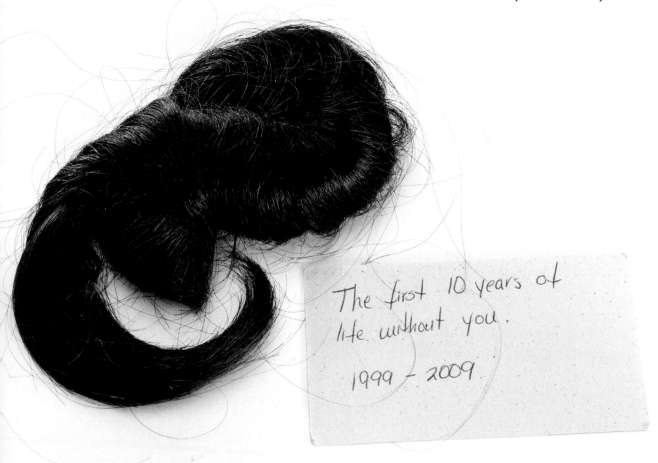

The first 10 years of life without you.

1999 – 2009

Kickboxing gloves

2014 to 2016
Dubrovnik, Croatia

WE HAD A GOOD RUN. Went through punches, sweat, heat, cold, opponents of all sizes. Time for this pair to be laid to rest and new ones to continue the run. This was a good relationship. We trained many, and we gave hope to many. I am going to miss them very much. But rather than just throwing them away I decided to donate them and make them mean something. They are the last remnants of a girl who gave them to me. These were intended to train her and only her. It did not seem to work out with her. But these gloves did wonders for me. They stood by me until their breaking point.

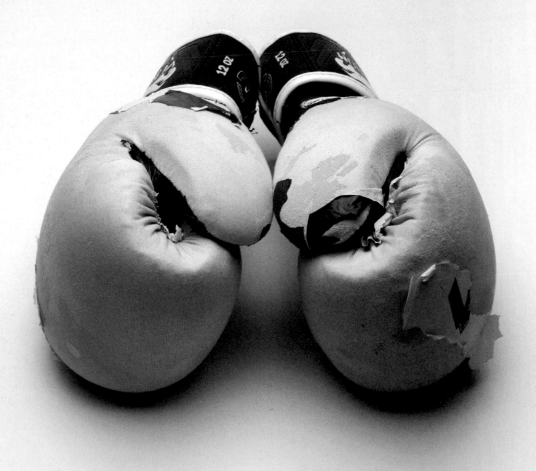

Olinka Vištica and Dražen Grubišić

Red wig

July 2007 to March 2008
New York, New York, United States

WHEN SHE RETURNED the clothing and CDs I had
left at her apartment, my ex-girlfriend sent me this
wig I had never seen before, without a note. I can
only assume it was obtained before our breakup,
in preparation for a fantasy fulfillment.

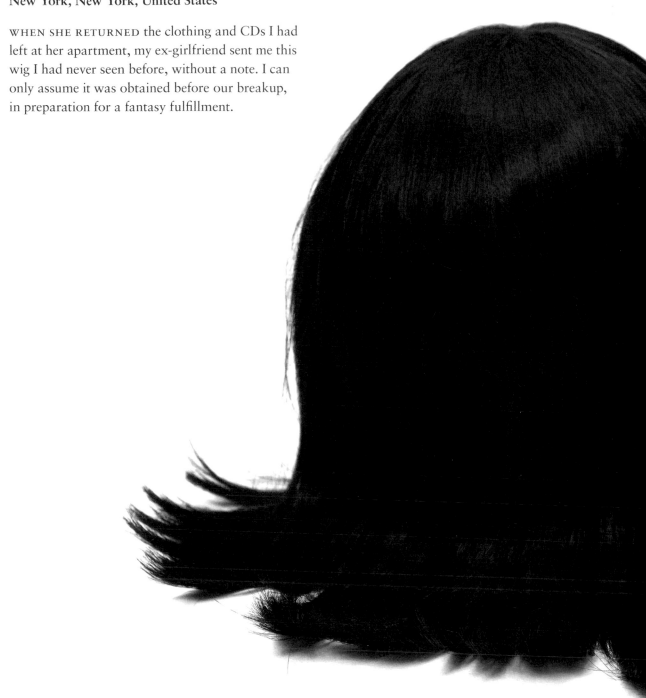

Broken riding crop

December 15, 2015, to March 16, 2016
Los Angeles, California, United States

I AM DOMINANT. He is submissive. The crop broke during one of the scenes we did together. I will always feel like it represents my broken heart very well. I ended the relationship because I fell in love with him and knew he would never love me in return.

Olinka Vištica and Dražen Grubišić

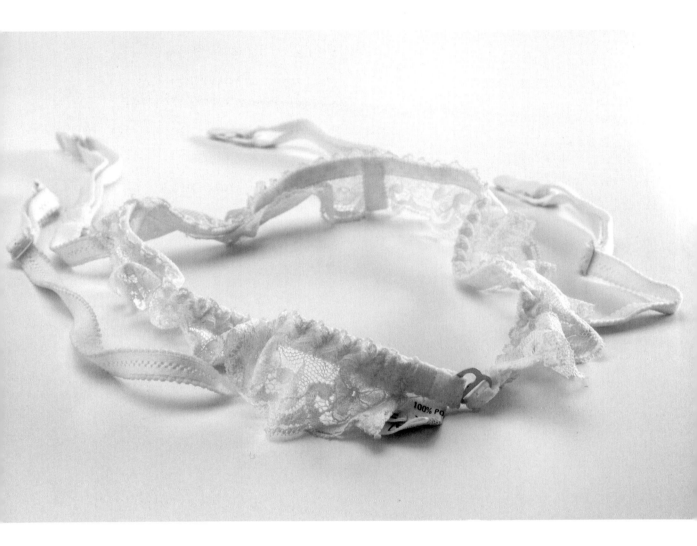

Garter belt

Spring to fall 2003
Sarajevo, Bosnia and Herzegovina

I NEVER PUT it on. The relationship might have lasted longer if I had.

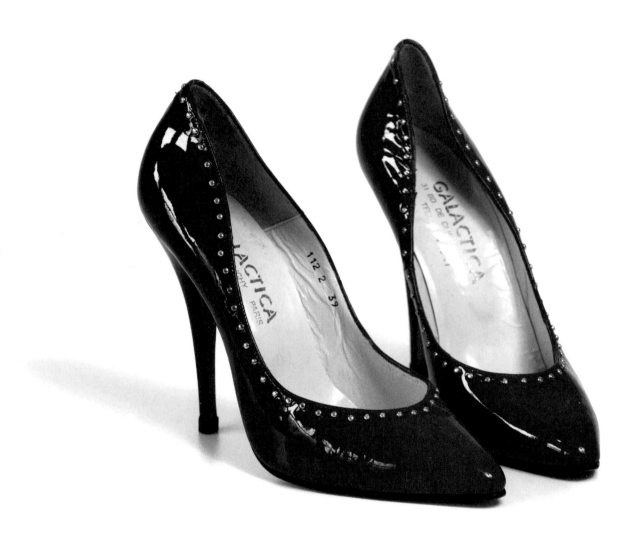

Red shoes

2 years
Paris, France

HE GOT THESE shoes for me at
a sex shop in Pigalle.

Olinka Vištica and Dražen Grubišić

Jim Bean Zippo lighter

On and off for 1½ years
Pittsburgh, Pennsylvania, United States

THE FIRST TIME I saw him light a cigarette with the lighter I wanted to punch him in the throat. I found it incredibly pretentious, pompous, and tacky, and I wrestled with my heart because all it wanted to do was claw its way outside my chest and nuzzle in his hands. It was like I had my own version of Dean Martin in front of me. The shine from the sunlight reflecting off the lighter almost blinded me. His smile came in a close second with a freshly lit cigarette resting coolly between his lips. When nerves hit him, he would open and close the lighter in his pocket until the day he opted to hold my hand instead.

His family moved and left him to close the house. We spent one of the best weekends of my life in an empty house, amid a fortress of boxes, on a mattress on the floor. We went to dinners, went to our favorite bars, and got high off of each other's touch. I still don't know if it was the secondhand smoke or his coffee-colored eyes registering every pore on my body, but it felt as if my lungs had been punctured and were collapsing every time I met his gaze.

Monday morning came and he cradled me, running his fingers through my hair as we lay there, avoiding impending doom. The silence was deafening. All I could hear was the burning of the cigarette which actually sounded like a ticking time bomb to me, knowing that we would separate the minute that cigarette was screwed into the ashtray. We stood up and got dressed. We had said everything, and all that was left was to confront reality and stare each other down. Ten seconds in, we both cried and embraced and kissed desperate kisses. He flipped his lighter open and closed as he said goodbye, until he fell to his knees and gripped my hips. He placed it in my back pocket and said nothing else.

I hope he is content and flourishing wherever he is. We promised to never speak again because it's too difficult. I'm not a smoker. Oh but how I sometimes long for nicotine-soaked smiles.

Russian condoms

1 year

Bloomington, Indiana, United States

RUSSIAN CONDOMS given as a gift from my
girlfriend's trip to Lithuania. Haven't used them
with her, nor with anyone else since.

Olinka Vištica and Dražen Grubišić

Modem for Commodore 64

June to December 1988
Zagreb, Croatia

HE JOINED MY CLASS in the sixth grade of elementary school. It was love at first sight. We exchanged glances across the classroom and teased each other until we finally finished school. For a short while we even sat on the same bench. After elementary school we didn't see each other for a few years, since he went to high school in another city.

Then one day, just before the end of high school, he suddenly walked back into my life. We spent an amazing six months together. During that time I enrolled in the university, and he was preparing to leave for Canada.

His stay in Canada was meant to last a few months, but we haven't seen each other for twenty-four years now. He left the modem as a memento before leaving. He had built it himself back when we shared the same classroom, possibly even the same bench.

He had won second prize for it at the state competition for young IT scientists way back in the eighties. Now already in the past century.

Alfonso Lara Castilla por
o el gusto de tantos
acado algún provecho
sajes positivos que
EDA, obra pionera de
onal y uno de los
rotundos de todos

El Editor
LUIS RAMÍREZ COTA

Con admiración. . .

A los hombres comprometidos
consigo mismos, conscientes de su
naturaleza, situación y potencial,
en búsqueda continua de nuevos
retos y excelencia, que les
permitan sentirse satisfechos en las
diferentes etapas y actividades de

Book

1984 to 1986
Mexico City, Mexico

A BOY WHO USED to walk me to school gave me this book.
I wasn't more than thirteen at the time; he was perhaps a year older.
I liked him, but when he became sick and had to be in quarantine,
I couldn't see him. We made up an alphabet, so we could write
to each other. That way we could send one another letters.
Our families had forbidden us to talk on the phone, but his mom
helped us communicate this way. In this book, there is a poem he
wrote for me, using our alphabet. Soon after that I stopped seeing
him because the religious people in our community didn't want us
to be together. They threatened to tell everyone that I had sinned
with him, that we had had sex. He did not want to tarnish my
name, and so it ended there.

Twenty-five years passed before he found me again, through
Facebook. When we saw each other, the affection and love were
still there for both of us. But it was all in vain. He was engaged
to be married.

Olinka Vištica and Dražen Grubišić

Little rubber piggy

February 2012 to January 2013
Jerusalem, Israel

HE GAVE ME THIS piggy when we met on a student exchange in the United States. It was just a joke over how much he loves bacon and my never wanting to taste it, as my heritage forbids it.

Many evenings we spent together at home drinking some wine and cooking dinner. Loving and annoying each other. Enriching each other with family memories and favorite foods.

How different our habits and clothes were, how different our food, from Israel and Denmark. And yet we are so much the same.

We loved each other purely and deeply, we loved our differences, and we both knew that was part of our charm. Imagining our children was like imagining how it would feel to win the lottery. But for me it was too hard to change my path, to hurt my parents, who only wished for me to be happy, with a Jewish boy.

I made the wrong decision; one that was not fully and consciously my own.

Here I am standing, twenty-seven years old, like a toddler learning to walk, I'm learning I can make my own decisions in life. Only now do I know, falling in love has changed my destiny, and for this I am grateful.

Maybe I evolved too late for this wonderful, wonderful person, but I know it's never too late to change. I'm giving you a glimpse at my piggy and a taste of our story, hoping we will all have the courage to consciously make our own decisions and the will to stand behind them.

I will always follow my heart!

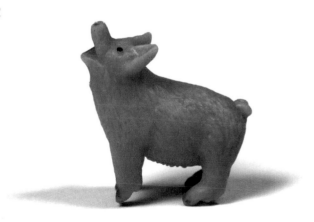

Postcard

Unspecified time
Yerevan, Armenia

I AM A SEVENTY-YEAR-OLD woman from Yerevan, the capital of Armenia. This is a postcard that was inserted through the slit of my door a long time ago by our neighbors' son. He had been in love with me for three years.

Following the old Armenian tradition, his parents came to our home to ask for my hand. My parents refused, saying that their son did not deserve me.

His parents left angry and very disappointed.

The same evening their son drove his car off a cliff.

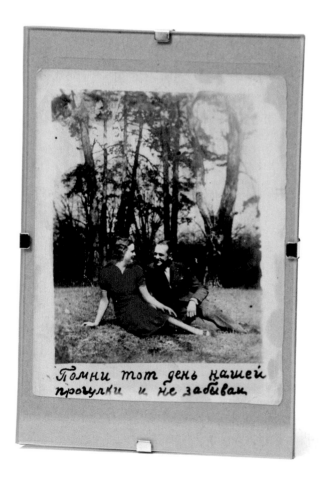

Olinka Vištica and Dražen Grubišić

Rhinoceros

5 years and 7 months
Dannstadt-Schauernheim, Germany

Dear Steffen,

Rhinos are among the primeval animals of our planet—and the most endangered ones.

So is it with our love. From the beginning we did not do enough for the growth of our love. We exposed it to dangers, left it alone, and did not take a stand for either its protection or its preservation. You are surrounded by ramparts and by a ditch no one can cross. It was not just an empty threat to our species—we died.

Maybe love is an endangered species? I wish people would respect and protect this special feeling and the person who makes it happen... Maybe each of us should commit himself or herself to "Love Protection International"?

"We were wrong about us; it was a beautiful time."

—Johann Wolfgang von Goethe

Two figurines

10 years
Dublin, Ireland

THESE TWO LITTLE FIGURINES symbolize my two children. Today they are in their thirties.

My heart was broken in England in the 1980s when I could no longer accept my husband's vicious temper. Our elder child bore the brunt of it, and I simply had to take responsibility for my children's safety. We left without my husband's knowledge and traveled to Ireland by boat on a winter night. We came with only the clothes we were wearing. Ironically, it was my elder girl who was most distraught. "Leaving Daddy behind" was the hardest part.

A couple of years later, when we had settled into our new life, I purchased these two little figurines to remember these sweet little girls. The older one loved writing letters to her dad and the younger loved knitting... Note the inscriptions on the bases: "Wishing you a warm and cozy winter" and "He hasn't forgotten me." My husband never improved his mean temper, but the girls still keep in touch.

Olinka Vištica and Dražen Grubišić

Ceramic rolling pin

From birth to 1981 (6 years)
Bedford, United Kingdom

ALL THE PHYSICAL memories of my mother were burnt, discarded, or buried. The most difficult part was that no one ever talked about her so I had nothing, except for a ceramic rolling pin that, surprisingly, survived the anger and emotional cleansing of that time. I kept it, wrapped carefully for each house move I made over the years.

This was mine to hold on to, to remember the moments of being in the kitchen with mom as a small child making gingerbread men. A powerful memory evoking the actual feelings and memories of the day, the smells in the kitchen, the smell of my mom, being included, feeling happy.

In October 2010 I was reunited with my mom.

I now feel able to move forward in my life, and donating the rolling pin means I do not have to cling to it anymore.

"Let the good times roll!"

Collection of various strands of old barbed wire

1993 to 2007
Conifer, Colorado, United States

THE BARBED WIRE belonged to my father. He was a junk collector and had the barbed wire sitting in the garage at my home in Conifer. It was among the few objects he left behind. He had never acted like a father. He was never a caregiver or participant in my or my siblings' lives. I haven't spoken to him since 2007 when my parents divorced. I have no desire to contact him in the future and want to stop feeling like a poor, broken girl because I never had a relationship with my dad.

Olinka Vištica and Dražen Grubišić

Souvenir

13 years
Lincoln, United Kingdom

A SOUVENIR from the best and the worst holiday of my life: Disney World, 1997.

You stood at the entrance and promised to bring us back there one day. Mom told you not to make promises you couldn't keep.

I have given up trying to make sense of your rejection of your two little girls, as I have come to realize no explanation would help me forgive you.

Thank you for all of the lessons you taught me and the strength you left me with, without even realizing it—without even being here.

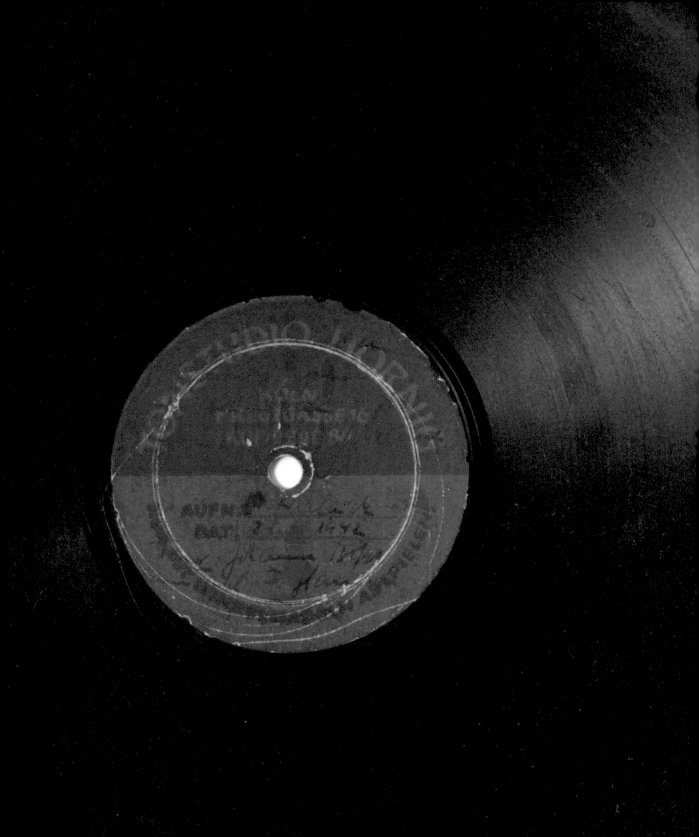

Shellac record, 1942

1940s
Cologne, Germany

MY FATHER HAD his heart set on becoming an opera singer. At the age of fifteen he had already begun to train his voice and had singing lessons. In 1942, at the age of eighteen he gave a record of himself singing Schubert's song "Adelaide" to his first girlfriend and love. Then he had to go to war. He was severely wounded—shrapnel from a shell penetrated his throat, damaging his vocal cords. Thank god he was healed in British captivity! His voice, however, was irretrievably impaired, and his dream of becoming a singer was destroyed. On top of that, when he returned from the war, he learned that his girlfriend had started seeing another man.

My father met my mother, fell in love with her, and married her. They had children and lived happily until his death. When my father's first girlfriend passed away, her sons gave me this record, which she had kept all her life.

Small deer made of bamboo

2 years

San Francisco, California, United States

I HAD A FRIEND, Tyler Antonio Montelleone. He grew up in Reno, Nevada, went into the military, and spent four years in Iraq and Afghanistan, then returned to get a forestry degree at the University of Nevada–Reno. He lived on the edge, loved plants, loved mischief, and fell in love with a woman he met while working for the Department of Public Works for Burning Man, LLC. He and his girlfriend had been living together in Reno for several months before she decided to return to the East Coast and finish getting her own degree.

The day she left, he went out to the desert with friends. He had been agitated all day. The PTSD he suffered from had been acute for a few weeks. His girlfriend had had to sit on him to keep him from hurting himself. Early the next morning, around 2 a.m., he and his brother and some friends went driving very fast on a bad dirt road. His brother insisted on driving because Tyler was upset and intoxicated. The truck ran out of gas. Tyler stayed with the truck while the friends left to get some. Then he remembered he had a full gas can in the back so he filled the truck and drove to catch up. This time Tyler refused to let his brother drive. He also refused to put on his seat belt.

When the truck stopped rolling, Tyler's brother realized his glasses were broken. He reached over and felt the driver's seat, and it was empty. When he found Tyler, after crawling on the dirt and rocks and calling out, there was nothing he could do.

This is a small token of memory his mother made. Now that I have told this story, I don't need it anymore.

Olinka Vištica and Dražen Grubišić

Breathalyzer tube

Undefined
London, United Kingdom

AN EVENING OUT in Brighton started with my getting a parking ticket: Bad Luck #1. We then spent several hours in Brighton Eye Hospital after he got glass in his eye: Bad Luck #2. The following morning I crashed my car and was Breathalyzed: Bad Luck #3.

Except that if it hadn't been for the glass, we would have carried on drinking, and then I would have been over the limit and lost my license.

Until this seemingly disastrous evening we had just been old friends, but we soon became more. So for all the bad luck, it ended up being one of the best nights ever. I've kept the Breathalyzer tube ever since.

Set of acupuncture pens

2007 to 2009
Pittsburgh, Pennsylvania, United States

DURING THE TWO YEARS we were together, I was constantly sick. She strongly believed in Eastern medicine and made me special soups, drinks, and herbs. She ordered this special set of acupuncture pens for me. I never used them. My health changed almost immediately after we broke up. I rarely get sick now.

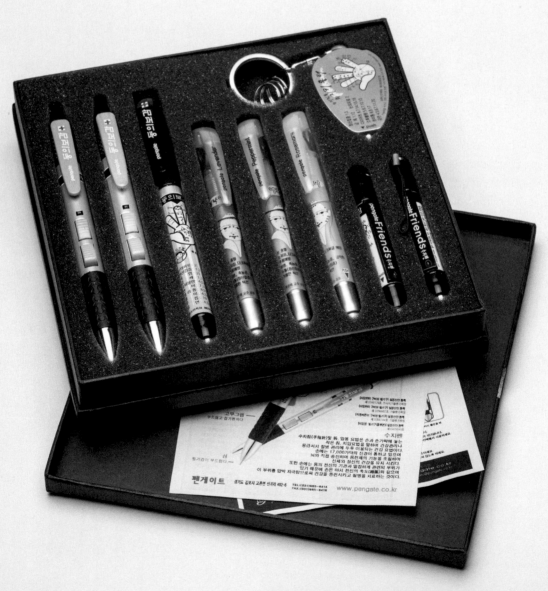

Wedding favor

1979 to 2015
Boston, Massachusetts, United States

I LOVED HIM with every cell in my body. We met at some friends' wedding; he was the best man, and I was a bridesmaid. Six months after we met, we were living together in Boston, and three months into that, we were engaged. We married in October 1980. We were early in our careers and had little money but managed to buy a tiny house outside of Boston with an unfinished upstairs. We finished the house ourselves and shortly thereafter had our first precious son. Later and in another, bigger house, a daughter came. Twenty-five years went by in a blink. Kids grew and went to college. He was a good dad, and we spent vacations in national parks, Disney, the beach. These were the best of times.

But then some light switch went off. He no longer wanted intimacy. He spent more and more time with his brother and less and less with me. Worse yet, two years ago, he treated my breast cancer diagnosis like I was overreacting to a common cold. The day after a first surgery, he left me sitting on the couch to go be with his gun buddies, saying, "Well, you really don't have cancer anymore." He dismissed the chemo saying I was being a drama queen. After treatments, he never asked about my health again. I vowed to get better and move on.

His increasing love of guns was the last straw. I could physically feel my heart break as he told the divorce lawyer that guns were more important than me. He had to say it twice, because she didn't believe he would actually say this. He didn't say it to hurt me. He said it as a matter of fact. I cried for three days.

I don't know what mental illness or combination of long-term drugs caused all this. I don't want to believe that he is the person I married in 1980. I want to believe that it was someone else. I know I don't want 2015 Him in my life going forward.

I found this wedding favor in an old jewelry box. It reminded me of how happy that day was and how much I loved him for such a long time. I wish I had 1980 Him and that love back, but it is to be no more.

IVF equipment and accompanying bag

9 years
Helsinki, Finland

MY HUSBAND FOUND another woman while we were undergoing fertilization treatment. While I was injecting myself with hormones and hoping for a child, he was starting a new relationship, planning a future with another person. He left me the day after the embryo was transferred. This equipment and six frozen embryos remain from the treatment. Nothing remains of the marriage.

Olinka Vištica and Dražen Grubišić

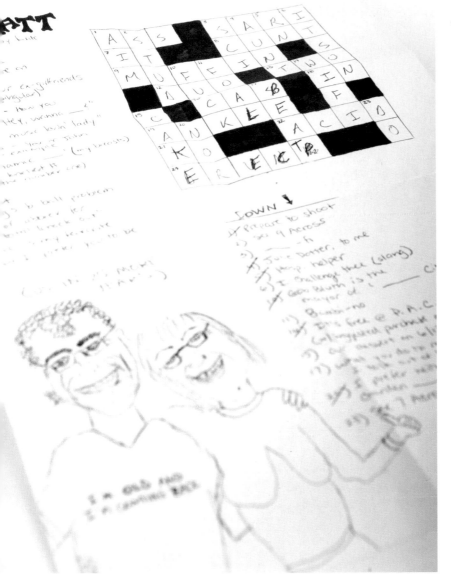

Crossword puzzle

July 2006 to October 2008
San Francisco, California, United States

KATE AND I USED to do the *New York Times* crossword puzzle together on the weekend. It was my first introduction to the format, and I continued the habit long after the relationship ended. Normally, we would finish about half the puzzle before giving up and writing in absurd answers to each of the clues, so she made this puzzle for me as a birthday present during the first year of our relationship. Looking back, many of the clues remind me how much she made me laugh, but there was also evidence of the cutting remarks that would ultimately be our undoing (see 3 across).

Origami Flowers in a Flowerpot

January 12, 2012, to March 3, 2014
Jacksonville, Florida, United States

I WAS DATING an emotionally unavailable policeman. He didn't believe in gifts of a tangible nature, especially for a holiday. But on Valentine's Day 2014, he got home from his shift at 7 a.m. and woke me up. He gave me these flowers he had made, and I cried. It was the most special thing he had done.

When I look at those flowers, my heart breaks, because I know we will never be together. But even when I travel overseas for work, I can never bring myself to throw them away. I always end up packing them up.

Olinka Vištica and Dražen Grubišić

Chaplet

1991 to 1994
Budapest, Hungary

THE CHAPLET HAS finally found a new home.

In the 1980s I had a high school sweetheart named Esther. She was religious, and one day she left her chaplet on my desk, and neither of us realized it. A few days later we had a car accident. She died and I lived. When I got home after the tragedy, I saw this chaplet lying on my desk. For many years I was suffering and agitated, trying to find explanations for why the accident had happened like that. I had a terrible sense of guilt.

Two years later I went to the fire station of the brigade that saved my life, and I became a firefighter, saving lives every day.

Though I had not been the driver that day, I never wanted to drive a car after the accident. But after fourteen years, life persuaded me to learn to drive because of my job. I put the chaplet on the rear-view mirror and it protected me on my journey.

My recent girlfriend, Kriszta, asked me one day why this was in the car, since I am not religious. At first, I could not tell her the story; I could not talk to anybody about this story. But the stress and suppression were making me sick inside, and when it became unbearable, I finally looked for help. In therapy, I managed to overcome my sense of guilt, and I've been a new man ever since. I could tell Kriszta the story of the chaplet.

I have closed down my past, and now I am concentrating on the future. I gave up firefighting after ten years, found a new job, and now I am leaving home for a new country, for a new life. I sold my beloved car and was searching for a new, remarkable home for the chaplet. Last year we stumbled across the museum in Zagreb, somewhere the chaplet can find rest and peace and tell its story.

Prayer mat

2009 to 2011
Amsterdam, the Netherlands

F. FLEW INTO MY LIFE on a Turkish Airlines flight from Istanbul to Amsterdam. He ate *everything*, he emphasized, before he came to dinner at my house for the first time. That night we drank the bottle of wine he brought. The next morning, when I asked him if he wanted to pray, he gave me a surprised look but didn't answer. A few months later I unexpectedly found him on his prayer mat in the corner of the room. After that, his prayer mat had a fixed place in my living room, together with his slippers. Did it indicate a higher level of trust, or did his need for religious rituals become stronger in my agnostic presence? Or did he want to emphasize his position in my life with his shiny, golden prayer mat?

The last time he stopped by as a "good friend," he took off his shoes and looked for his slippers in their usual spot. "Did you throw them out?" he asked. Absolutely not. They were stored, with the prayer mat, in a cupboard in the attic. "You'll find them easily enough," I said, pointing up. He left them there, untouched.

Olinka Vištica and Dražen Grubišić

Toy motorcycle made of wood

September to December 2013
Mexico City, Mexico

MY EX-GIRLFRIEND gave me this motorcycle. She hated that I rode motorcycles and even vowed that she would never ride mine. Soon after we began dating, I had an accident. I broke my leg and had to wear a cast and stay in bed.

One day she brought me this toy motorcycle. At first I thought it was a nice gift, until she said, "Bringing you this seems fitting seeing as how you are only capable of taking care of something of this size. You'll have to get yourself a toy woman, too, because I seriously doubt you can handle a woman like me."

I decided I never wanted to see or hear from her again. We haven't spoken since.

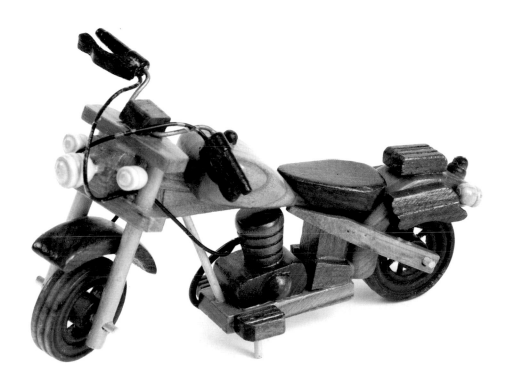

Blue jeans that had to be cut off my husband after a motorcycle accident

1983 to 2009
Hailey, Idaho, United States

MY HUSBAND, the father of our children, was hit by an elk on his motorcycle one summer evening. Even though he had on a full face helmet, his brain suffered a contrecoup injury; after surgery he spent four months in a rehab hospital. He is wheelchair-bound now because of contractions in his legs. He is able to talk, although his reality is very different. He time travels to different decades of his life, locations, and people. He is still here, but I have had to learn how to live with a broken relationship, a one-sided relationship.

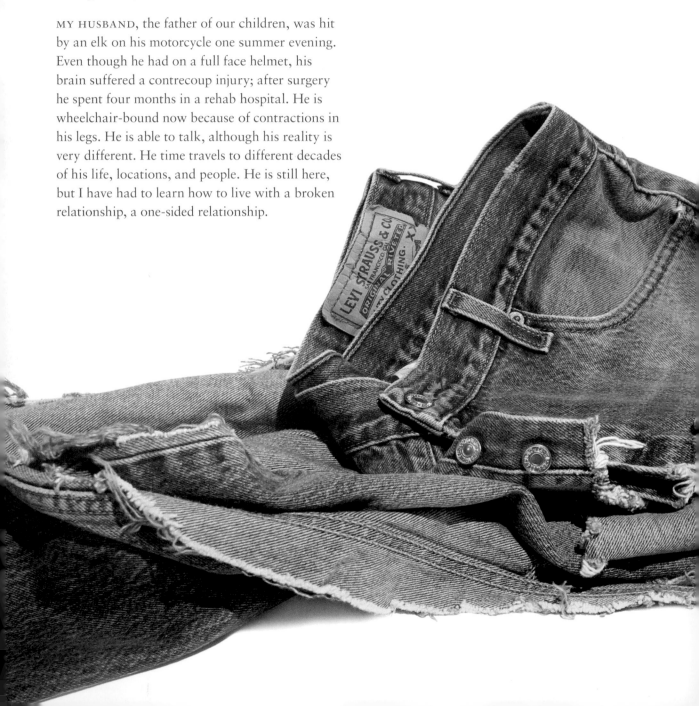

Elbow-length white gloves

My father is still alive
Boise, Idaho, United States

MY FATHER WANTED ME to be a certain kind of girl, a girl I could never be. It was impossible to win his love, but I tried. These white gloves symbolize that effort: the disconnect between who he wanted me to be and who I was. I wore them the night he presented me at a debutante ball—an arcane ritual that somehow still delineated those who mattered, meaning those with money, in my hometown. Even though my father had abandoned our family long before, he insisted that he be the one to present me to society. And so I donned these gloves and a ridiculous white gown: I curtsied, and my father stood next to me—a photographed moment of a lie. I threw up afterward. I knew whatever relationship I had with my father would remain fundamentally broken. I wasn't the girl in the evening gown with long white gloves. And yet I've kept them all these years. I'm not sure why anymore—my relationship with my father is still broken. It's time to let go, wear my own skin.

Japanese sword

1999 to 2001
Vancouver, British Columbia, Canada

SHE WAS MY first real love. We did everything together; traveled together. Our relationship was going downhill and on my birthday, instead of buying me a gift, she gave me a sword she had brought back from Japan when she was a teacher there.

The significance is that the sword she gave me was not a katana, but in fact a hara-kiri which is the sword one uses when wanting to commit suicide. Shortly after my birthday our relationship ended, and it took me a long time to get over her completely and let go of her memory.

Olinka Vištica and Dražen Grubišić

Photograph

October 15, 2006, to September 15, 2016
Denver, Colorado, United States

THIS IS ONE of a series of gifts I received from
her on my twenty-first birthday, more than seven
years ago. There was another version, her pride
of the bunch, that was enlarged and printed on a
professional backing, something that looked fit to
be displayed on a gallery wall. I burned that along
with the rest in a tinfoil turkey pan on the back
porch of our apartment, alarming our neighbors,
I'm sure, with the flames.

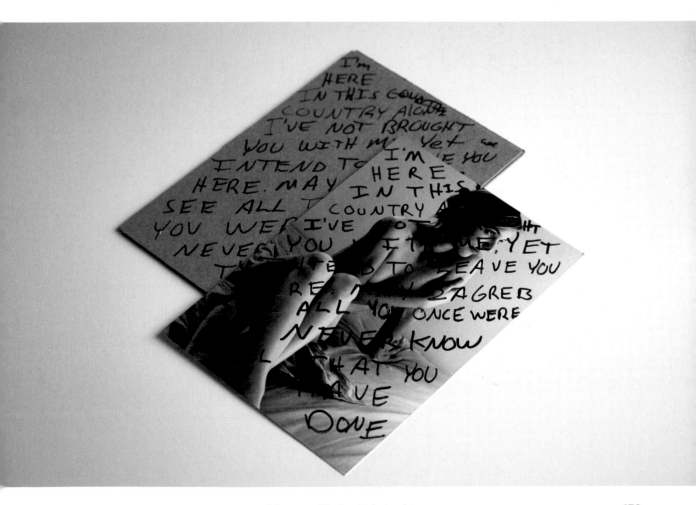

Melted phone

2009 to 2013
Lexington, Massachusetts, United States

I WAS THE LANDLORD of an apartment in
Lexington, just a few blocks down from my
house. The couple who stayed there fought
often, and I assume they broke up after I evicted
them. They weren't very happy with each other.
Cleaning up the apartment after they left,
I found this flip phone in the oven. I think
one of them put it there to spite the other.

Olinka Vištica and Dražen Grubišić

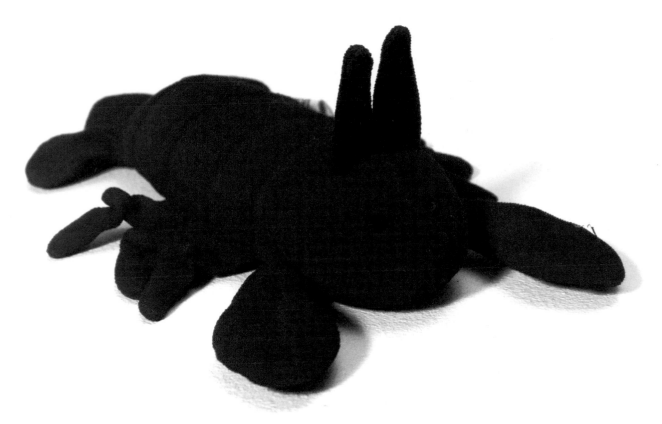

Stuffed lobster

3 years and 3 months
Sarajevo, Bosnia and Herzegovina

HE WAS CHINESE. He was beautiful. We met as
students in America. One summer, while I was
in Sarajevo and he was in Singapore, he sent me
a *stuffed lobster*. He was thinking of me. How
are lobsters and love connected? Nevertheless,
I shared the bed with it. The lobster, I mean.
And later with the man who gave it to me.

姓 名 王士琛

性 别 男 年 龄 21 岁

注意：一、凭证参加选举

二、只准本人使用

上海市杨浦区选举委员会

2011年 11月 16日

Electoral certificate

2011

Shanghai, China

THIS IS HIS electoral certificate. He gave it to me and entrusted me to vote in the election of the National People's Congress, since he was going to be abroad during the voting period. I never imagined this would be the end of our relationship. I have kept this certificate in my purse all this time, as if I were keeping our beautiful memories with me. It has been three years since I decided to leave him. Still, I miss him, and I really appreciate all that he taught me. I wish him a promising future and a happy family.

Olinka Vištica and Dražen Grubišić

3 bridesmaid bouquets, letters from Afghanistan, and medals

2008 to 2016
Hornbæk, Denmark

WAR AND LOVE. A love that was not strong enough to endure the war. Many years of waiting on a husband and father who came home and left us.

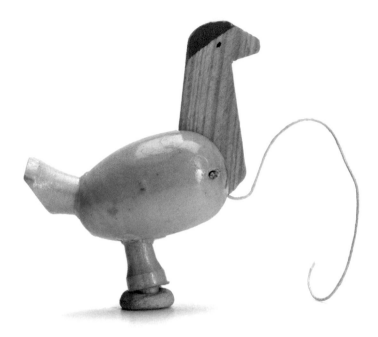

Wooden Rooster

19 years
Mexico City, Mexico

THIS WOODEN ROOSTER came with others, in a traditional Mexican game. It was a gift from my dad, who broke my heart.

My parents separated when I was nine. One day, when I turned fifteen, I asked him why he never hugged me, and he said, "I've always doubted that you were really my daughter."

He was drunk.

Something cracked inside me. How could he say that? I look exactly like him, my eyes, my mouth, my eyebrows; I have many of the same tastes and the same way of talking. I'm so much like him, and he rejects me?

It was months before I saw him again. He cried and kept asking how I could see so much of him in me when he could not see it? I resented him.

When I was nineteen, he got cancer. Seeing him like that was very painful. He was such a strong man. He died, and I cried more than ever. I forgave him and tried to forget the sad and ugly moments he had afforded my brothers and my mom. Sometimes I still remember him with resentment, sometimes with love, but now much more often with love.

Today I'm twenty-six and looking at this object I only remember his generosity. He always gave me clothes and toys that I did not like, but that never stopped him. Perhaps it was the only way he knew how to say "I love you." Perhaps it was his way of giving me that big, warm hug that I always wanted.

Olinka Vištica and Dražen Grubišić

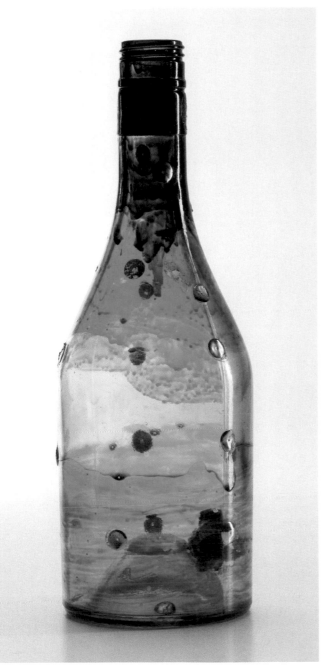

Bottle in the sea

39 years
Brussels, Belgium

THIS BOTTLE AND I have been inseparable for forty years.

I was with my parents in our house at the seaside when I found it on the beach, but there was no message inside. The message would come later that same day.

That afternoon, I was painting the bottle, customizing my treasure. I was in the office next to my father when, in spite of the background music, I overheard him on the phone. My father's voice changed, and, after he hung up, I could sense that he was worried. He went to see my mother, who was painting at her studio, to tell her about the conversation. Being only five years old, I didn't understand much, I only know that my mother started crying. I was hiding behind an armchair when I heard them say, "How can we explain to her that we adopted her but that she is our daughter, *my* daughter?"

Today, my parents aren't here anymore, and not a day goes by without my thinking about them. I miss them. I was a happy and fulfilled child. As a tribute to them I entrust you with this bottle, *my* bottle, and its history, *my* history.

Child's wartime love letter

May 1992 (3 days)
Sarajevo, Bosnia and Herzegovina

ESCAPING FROM SARAJEVO under fire in a big convoy, we were held hostage for three days when leaving the city. I had turned thirteen a few days before.

In a car next to ours was a little girl named Elma, with her mother and some other people, I don't really remember whom. I only remember she was blonde and incredibly cute. I fell in love, with childlike honesty, and confessed it to her with the same honesty in this letter. I had given her some tapes, since she forgot to bring her own music when we all left in a hurry. Just as I didn't get the time to give her the letter, because after three days they suddenly freed us and we lost sight of Elma's car near Travnik, she never got to return my Azra, Bijelo Dugme, EKV, Nirvana, and other tapes.

Naturally, I never saw her again, and now I just hope that the music reminded her of something nice in that whole terrible situation.

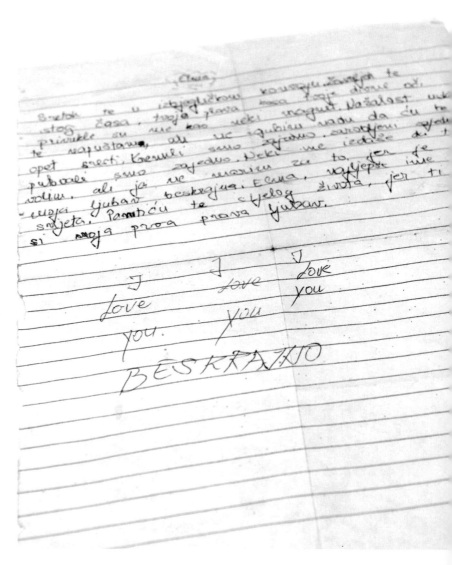

Olinka Vištica and Dražen Grubišić

Something to give away to end the story

2014
Garbahaarrey, Somalia

MY BROTHER WAS a driver. One day he was driving a bus full of people, and one of his passengers, a journalist, took pictures and published a story. The authorities found out who was driving that day. Then they waited for my brother to come back to the city and ended his life.

They proclaimed my family as spies, and that is why I had to leave my country.

My brother had called me that day saying he had something to tell me when he got back. But he never made it home.

I wish we could talk and laugh like we did before.

I feel like I am lying in a box—I can't get out, it is locked. I need to give something, to say goodbye, to end the story.

Amulet

8 to 10 months
Brøndby, Denmark

OUT OF THE BLUE, she gave me this small axe head as a birthday present. It was apparently from the eighth century. I thought this kind of thing could only be found in museums, but she had bought it from a private collector because she knew that I was fond of Old Norse symbols.

Later on, I made an amulet out of it with a little piece of string. I felt it possessed a strange kind of magical power at the same time as it reminded me of her. Once, when I thought I had lost it, I panicked until it reappeared.

When it was finally over between us, after one last exchange of Facebook messages, I decided to bury the amulet in the woods during a nightly ritual that involved an offering of blood, from which I still have a scar.

Several months later, walking around in the woods, I passed by the place where it was buried and almost without thinking, I picked it up.

I hope it ends up in a place where I cannot get hold of it anymore because, in my moments of weakness, I will probably regret that I am now letting it go.

Olinka Vištica and Dražen Grubišić

X-Files pin

June 2015 to January 2016
**San Francisco, California,
United States**

A NEW YEAR'S gift from the boy
I was with at the time. "I want
to believe" in this relationship.

Lottery tickets

63 years
Zaragoza, Spain

WE WERE FOUR FRIENDS. Four best friends for over sixty years. We shared everything. We did everything together: we celebrated birthdays, bought presents together, phoned each other every day, and visited each other when we were sick.

One day, however, I discovered they had been doing something without telling me: they had been playing the lottery. It is a tradition in my country to buy a special number at Christmas, together with your friends or family. How did I find out? Because they won a big prize. I felt so sad and disappointed when I found out that I fell ill. They didn't know what to say when I asked them why they hadn't told me; they only made excuses. The worst thing is that they never phoned me again. People told me they were too ashamed. Maybe. Only one of them contacted me again, sincerely apologized, and came back into my life. But the other two… They won the prize, but they lost a real friend. Losing friends is hard when you are young, but losing them when you are living the last years of your life is even harder.

Olinka Vištica and Dražen Grubišić

This Diary Will Change Your Life, 2005 (with stapled keepsakes)

January to July 2005 (6 months) and
on and off for 7 years thereafter
Brighton, United Kingdom

HE WAS TWENTY-ONE, and I was eighteen. It was like a Romeo and Juliet clusterfu*k, him all back-combed like Robert Smith and me skinnier than now and with shorter skirts and higher-reaching socks. He seemed to drop out of the sky and unlock so many avenues of art and cinema for a girl from the ghetto to explore, the most precious of which was the adventure of sexuality. He never lied about his girlfriend, but he lied about how he felt about her, and being young and stupid, I believed him. The diary I'm sending you is in part responsible for this. It contains every train ticket, every gig ticket, and every permanent mark that I felt important enough to make over those six months. We were "tasking buddies" and very much more. Six months after it exploded, I ran into him at the movies with my new partner, and we've been on and off again since then.

I'm sending you this diary because after seven years of being played with, I'm tired of being trapped in his voice. I want a shot at a love that's not second-best. This is a hopeful beginning, not a sad ending.

Plastic Godzilla adorned with beaded necklaces

1990 to 1992
Mexico City, Mexico

I HAVE KEPT THIS Godzilla for more than twenty years. It was a gift from a girlfriend who wanted to live with me. The relationship ended abruptly after I moved into my apartment.

One day I told her I loved Godzilla movies, the ones I had seen on TV when I was a kid. After we separated (on very bad terms), I used the Godzilla to hang some memories from my other girlfriends, such as necklaces and earrings.

From the top of my bookshelf, Godzilla's fierce eyes have witnessed all the comings and goings in my apartment. After all these years, I think it's time he followed his own path.

Olinka Vištica and Dražen Grubišić

Goalkeeper gloves

2007
Zagreb, Croatia

A LESBIAN SOCCER TEAM. She was offense, and I was goalie, playing soccer for the first time in my life. I could tell the cute, blonde, boyish girl liked me—she usually scored without a problem, but there she was, stumbling in front of my goal. Whenever she got near me, it was as though she didn't know what to do with the ball, what to do with her legs, or what to do with her eyes. It amused me—she liked me.

Once, when we were training, she took out these old gloves and gave them to me. They became a sort of sacred object, and I started training regularly. If only we could have kept it at that. The problem was we both were already in relationships. In fact, her girlfriend was also a forward on the team. She kicked me in the head with the ball more than once—and rightfully so.

We were all hurt, and no one was happy; 1–0, you could say. The blonde and I lost our way and perhaps went a bit too far.

Olinka Vištica and Dražen Grubišić

Picture painted in acrylic

July 29, 2012, to December 16, 2013
Cuernavaca, Mexico

THIS SMALL PIECE of painting that I want to donate is called *Micropapilomatosis*, and it is a small representation of the generous "gift" from my ex, along with debts to the gynecologist. And since I can't donate this virus because that would mean tearing out my vagina, I'm giving it to you in this little painting.

Pencivir herpes cream

7½ years
Cologne, Germany

I MET GEORG on a carnival Saturday. He suddenly appeared in front of me in the crowd, wearing a homemade Superman costume. I asked him if the outfit also reflected what was on the inside. He told me to give him a try.

We did try. For seven and a half years. In the end, he realized that I had actually never been his type. About three years into our relationship I picked up oral herpes from him. We would laugh about it whenever the infection broke out again.

One evening after the breakup we were standing with a group of people and I couldn't help pointing at the herpes on my lip and saying to him in front of the others, "That's the only thing of yours that I've kept." What I actually thought was, "That is the only thing from you that has remained with me." Every year, just recently on carnival Saturday, I treat fresh herpes blisters with this cream. When I do, I think of Georg and pensively stroke my lips.

Olinka Vištica and Dražen Grubišić

Tibial screw, implanted and removed surgically

March to May 2015
New York, New York, United States

OURS WAS A CONNECTION that felt destined by the stars. Our best friends had dated, but a series of missed encounters, ill-timed relationships, and chance passings kept us from meeting—until one day they didn't. The fall was fast and hard.

We hadn't been together long when I learned I would need an operation that required three weeks of bed rest and another five on crutches in New York City.

I offered him an out; I knew it would be a lot so soon in the relationship, but he insisted it would be his chance to shine. He'd cook me dinners and screen all of his favorite films for me, bring me flowers and hold me as I'd drift off into an opiate haze. I didn't understand how he could be so excited and confident, but he was.

He promised me again and again that I would not wake up from anesthesia to find him gone.

Mattress springs

19 years
Zagreb, Croatia

After nineteen years he just left one day.

He was in love for the first time in his life, he said!

He told our kids they would not miss a thing.

He was still their dad.

Cold as ice he walked out.

Within the next hour I disassembled our bedroom and gave

it to one child so the other one got the kids' room all for himself.

The kids were so happy to have rooms for themselves they
shouted: This is the best day of our lives!

The absurdity of the moment was phenomenal: the saddest day
becoming the best.

Later, I separated the mattress he and I shared in two.

Using scissors and pliers.

People told me it could not be done but still I did it.

Made myself a single mattress.

His half went to the basement.

Like every cold metal skeleton should.

I still sleep on my half.

Four years now. So you see, it can be done!

Olinka Vištica and Dražen Grubišić

"Dark Vador" figurine

August 2007 to February 2013
Mons, Belgium

THIS IS A PRESENT I gave him for the last Christmas we spent together. Barely a month after that, during our separation, it got lost in the boxes and ended up misplaced among my things. By mistake. By omission.

Farewell to the dark forces of boredom and routine. Farewell to regrets. Farewell to remorse. I have refused to follow your path.

"If you will not fight, then you will meet your destiny" (Darth Vader, *Star Wars: Episode VI, Return of the Jedi*).

Violin rosin

2013

Warrensburg, Missouri, United States

WE'VE ALL HAD our high school sweethearts, right?

We met through a mutual friend, and the first hour we spent together was us talking about birds. I was amazed at how much she knew, and how strongly her passion showed even in a casual conversation. I dove headfirst into the most life-changing ten months I had had to that point. I wanted to keep up with her interests so that we could hold better conversations with each other. After digging though countless books on animals, from rats to snakes, after watching movies and reading books, I found a new interest for us to share that had nothing to do with animals.

She was first chair viola in the high school orchestra. For her, I knew I would move mountains, and I did. During my junior year of high school, I picked up an instrument for the first time in my life, and practiced until the tips of my fingers could not take it anymore. I was able to join the orchestra after only a few months of playing the viola. I was last chair, but there I was, playing only a few seats away from the girl I loved. She was beautiful, as beautiful as the music she played.

I thought I had it made. One day, out of the blue, she called me in to the school's library, and told me we should break up. I didn't resist as I honestly thought she was joking. Eventually, she told me she had fallen out of love with me weeks after our relationship began, but she was worried I would kill myself, as absurd an idea as that was. Shortly after, I moved away and spent my senior year in another high school; I bought a violin but never learned to play it very well. I eventually gave that violin away.

Not too long ago, I found this block of rosin. I will never make good use of it.

Olinka Vištica and Dražen Grubišić

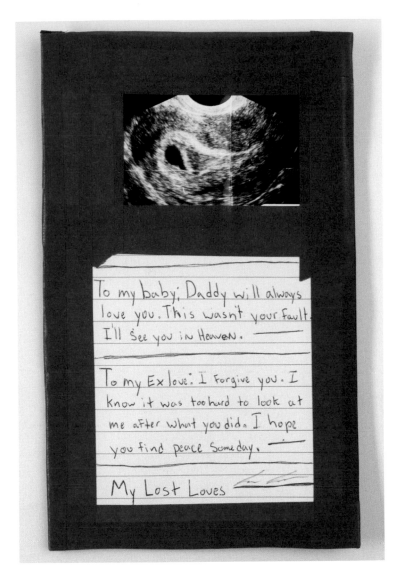

To my baby; Daddy will always love you. This wasn't your fault. I'll see you in Heaven.

To my Ex love: I forgive you. I know it was too hard to look at me after what you did. I hope you find peace Someday.

My Lost Loves

Ultrasound photo

May to September 2015
Boise, Idaho, United States

A WHIRLWIND LOVE destroyed
by a decision shadowed in guilt.

Box for 50 pistol cartridges with 37 left

February 17, 1979, to May 2, 2013
Basel, Switzerland

WHEN I CLEANED out his apartment, I found this package of cartridges in his bedroom. The police did not spot them; they took only the weapon. It was an ordinary-duty pistol, bought in 1997 with a permit. Otherwise there were not many personal belongings left. He had already carefully sorted everything out. Nothing more pointed to his state of mind. He had carried that secret with him for sixteen years. Now the only thing that remains are the memories of a relationship that started with my birth and ended on a random spring morning.

Olinka Vištica and Dražen Grubišić

Contact lenses

2012 to 2015
Oberlin, Ohio, United States

I CONTINUED to save them, curled up,
on my own bedside table.

Ex-axe

1995
Berlin, Germany

SHE WAS THE FIRST woman that I let move in with me. A few months later, I received an offer to travel to the United States, but she could not come along. At the airport we said goodbye in tears; she said she could not survive three weeks without me.

When I returned she said, "I've fallen in love with someone else. I have known her for just four days, but I know she can give me everything that you cannot."

I kicked her out, and she immediately went on vacation with her new girlfriend, while her furniture stayed with me. Not knowing what to do with my anger, I finally bought this axe. I needed to blow off steam and wanted to give her at least a small feeling of loss—which she obviously did not have after our breakup.

Every day, over the fourteen days of her vacation, I chopped up one piece of her furniture. I kept the remains there, as an expression of my inner condition. The more the room filled with fragments of wood, acquiring the look of my soul, the better I felt.

Two weeks after she left, she came back for the furniture. It was neatly arranged in small heaps. She took that trash and left my apartment for good. And so the axe was promoted to a therapy instrument.

Olinka Vištica and Dražen Grubišić

Almost-complete collection of *Lone Wolf and Cub*

December 2004 to December 2015
Reseda, California, United States

YOUNG LOVE BORN in Reseda, sort of like that song "Free Fallin'" by Tom Petty. He was so different from me and beautiful. Eleven years together, six of them married. The war got the better of us, and PTSD rears its unpleasantly unpredictable head at inopportune and unexpected times. He had the books before we met, and I read them not long after we started dating. He didn't take them when he left. He said I could keep them or give them away. I know what happens at the end of the series. Sometimes it's okay to let the story trail off unfinished.

Piece of artwork I made in response to what happened

Difficult to pin down— summer 2007
Penryn, United Kingdom

WHEN I LOOK BACK and revisit the past, there were moments of epiphany when I knew things were never going to be the same. Meeting Shev was one of those moments—he taught me all that's good about love. And I was watching the madness slowly consume him. The mania slowly crept up on him and was accompanied by new-found delusions of grandeur. It took about a month. The lucid moments became fewer and fewer, and it was like watching a long, slow, torturous, painful death. He felt it coming, "Sach, I know something's happening to me I just don't know what, but whatever happens, please remember I love you," he said. As his shadow-self emerged, his voice changed; and as his voice changed, the mania intensified; and as the mania intensified, he became sleep deprived. Soon he was caught in a loop tearing around Delhi trying to get it on with every woman who smiled at him, for he was suddenly God's Gift Incarnate. His most precious books, along with my letters, were torn up and scattered around the city that never sleeps. Sacrificial offerings to Shiva, the god of death, destruction, and reincarnation.

When he was finally brought around three weeks later, all that remained was a cold, closed heart,

barely beating,

running on lithium

"questions of science;

science and progress

do not speak as loud as my heart

tell me you love me

come back and haunt me

oh, and I rush to the start"

It's been five years and one month since Shev flew out of his burning bed to dance with Shiva's dead. There's not much left to remind me of us: one letter, a mug, a small picture of a naïve, or perhaps the word is *native*, dancing man, his grandmother's shawl, a handful of photographs, three silver bangles, Salman Rushdie's *Haroun and the Sea of Stories*, and four playlists, beaten with tears, scratched with wear, and stuck on a loop. The second one we made together on my last night in India, March 30, 2007, and the last time I saw Shev. We called it "A Moment a Minute aka Just Married." That was just before I fell asleep while we watched *Eternal Sunshine of the Spotless Mind*, our limbs effortlessly entwined.

For months, no, probably years those songs served as a conduit to transport me back so I could remember because I was so scared that I might forget. Today, five years on, I know I'll never forget. The details have faded and lie dormant in my cells, but Shev often comes when I'm sleeping to that liminal dream space somewhere betwixt and between.

Olinka Vištica and Dražen Grubišić

My mother's suicide note

1959 to 2007
Amsterdam, the Netherlands

Dearest H.

To write a letter under

these circumstances is almost impossible.

I wish you and M. and M. all prosperity possible.

And lots of love and happiness.

Your mama

Olinka Vištica and Dražen Grubišić

Crochet doily

2015
Latakia, Syria

MY MOM MADE IT for me when I got married.
She had pain in her fingers and had problems with
her eyes.

She made six small ones and one big crochet
doily. When I left Syria I couldn't leave without it.
It is like I have a part of my mom with me. And
now I give to you a part of myself and my mom.
I am proud of my mom and how she raised us.

Peter Pan plush toy

1991 to present
Woodland Hills, California, United States

I PURCHASED THIS little plush toy on my twenty-fifth birthday, as a reminder to always keep the little boy inside me alert, awake, and alive. It has sat atop my computer since that day to serve as inspiration. Alas, I now approach my fiftieth birthday, and the boy is lost to me. Grand dreams have rotted away, and imagination lies in a dusty corner of an abandoned house down the street, inspiration carried off by the autumn winds. But rather than just say all this, I think the caption for this little toy could be nothing more than "I grew up." Seems more elegant somehow.

Olinka Vištica and Dražen Grubišić

Red plastic chain

14 months
Basel, Switzerland

THIS IS a red plastic chain. My grandson liked
it a lot.

I loved him and he loved me—a great mutual
love. He played with the chain whenever I had it on.
Once he pulled it so vehemently that the clasp
broke and the chain fell off. My grandson died a
violent death at the age of fourteen months.

I cannot say that my heart is "broken." A piece
of it was torn away and crushed.

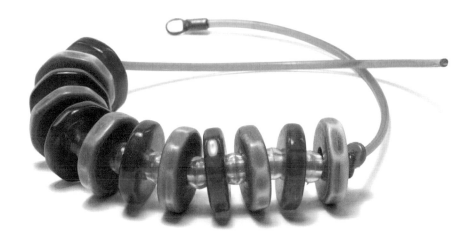

Pair of handcuffs

2011 to 2015
Edmonton, Alberta, Canada

THE SEX PLAY was fun, but I'm
happier to be free from your
shackles.

Olinka Vištica and Dražen Grubišić

Rubber shoes

Unspecified time
Manila, Philippines

IT IS SAID you should never give anyone a pair
of shoes as a Christmas present because the shoes
will then make them walk away from you.

A few months after Christmas 2004 we called
it quits.

Superstition? I don't believe in superstition.
I just walked away. Today I'm still walking, but
without the shoes.

Love letter on shattered glass

Unspecified time
**San Francisco, California,
United States**

THIS IS a love letter written to
the passion of my life (so far)
toward the end of our relation-
ship, ten years ago. We were
in different countries, and I'm
better at writing than telephon-
ing when it comes to these
matters (plus the cost of inter-
national calls was at that time
pretty steep). I sent an e-mail—
a fairly new mode of communi-
cation in our relationship at that
point—to ask what address to
send it to. He broke up with me
in a reply e-mail. I thought that
was lame.

I deleted his e-mail eventually,
but saved the letter I had written.
Since it was a sort of a relic—
an actual, handwritten letter—
I glued it to an old mirror I was
getting rid of and shattered it.
I thought it would be a cathartic
ritual and might look cool, too.
With the help of an X-ACTO
knife to tidy up the rough edges,
it is now preserved as a specimen
of an extinct species.

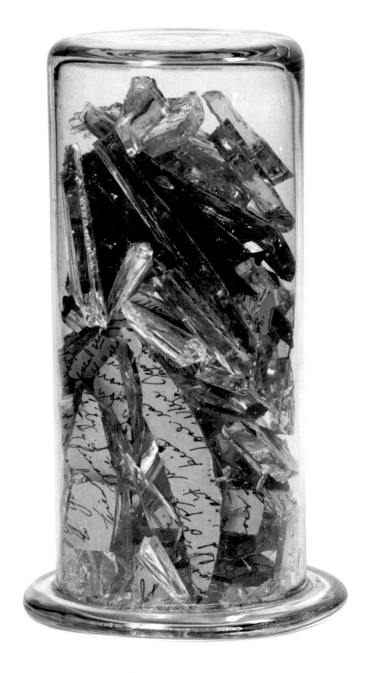

Olinka Vištica and Dražen Grubišić

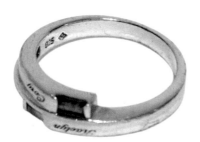

Promise ring

2006 to 2009
Pineville, Kentucky, United States

WE WERE JUST two kids who couldn't keep a promise.

Handmade clay fox

November 2011 to July 2013
Baltimore, Maryland, United States

ON THE NIGHT we first kissed, he saw a fox as he was leaving my place in a neighborhood outside Baltimore. Foxes became a symbol of our relationship, signifying mystery, surprise, and sensuality. They were probably fairly common in the area where we both lived, but as our relationship developed we often noticed them when one of us would drive home late from the other's apartment, a flash of red disappearing into the roadside brush, or even an imperious glance before the animal stalked away.

I don't remember when he made this for me, but we made a lot of things for each other, little tokens of our affection. It still holds a few partial fingerprints from when he shaped it with his hands. It's nearly weightless, but I've held it and turned it between my fingers dozens of times.

Olinka Vištica and Dražen Grubišić

Dog-collar light

13 years
Berlin, Germany

WE HAD BEEN married for thirteen years and were living in a foreign country together. The love in our relationship had taken a backseat to friendship and I'd come to realize I was miserable.

Telling her I was leaving was the hardest thing I'd ever done—at that time, anyway. She went back to her own country to stay with her family and took our little dog, which I thought she would need more than I did. She sent me a package with a few small things, each of which broke my heart. Most were about her wanting to take care of me, even though she was the one suffering more.

This little red light has traveled with me everywhere, in my toiletries bag for two years now, killing me every time I see it. It is a dog-collar light she bought for our dog, who kept wandering off in the dark winter nights and getting lost. This way, we could always find her.

My former partner took her own life a little over a year after we split up. Alone. In a hotel room. In a strange town. I am still alive, but…

P.S. Please hang it blinking if you use it in the museum—it reminds me of a heartbeat. The battery can be replaced.

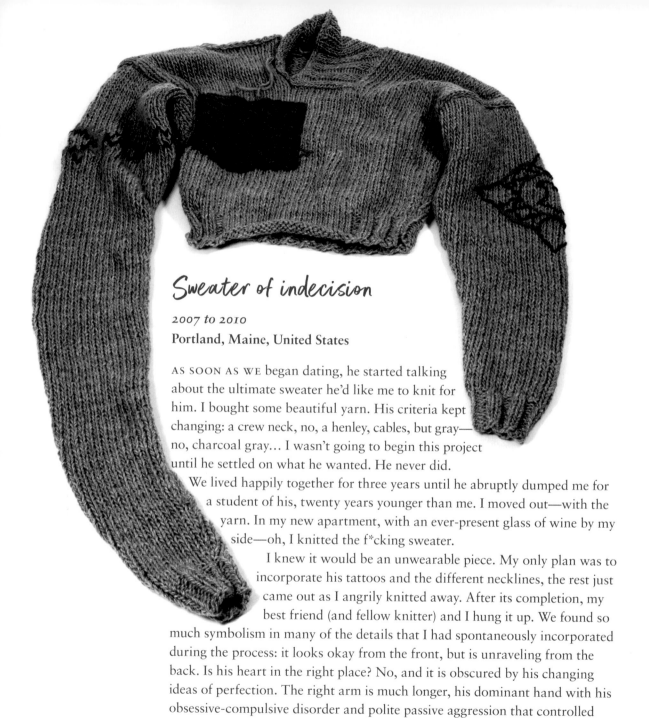

Sweater of indecision

2007 to 2010

Portland, Maine, United States

AS SOON AS WE began dating, he started talking about the ultimate sweater he'd like me to knit for him. I bought some beautiful yarn. His criteria kept changing: a crew neck, no, a henley, cables, but gray—no, charcoal gray... I wasn't going to begin this project until he settled on what he wanted. He never did.

We lived happily together for three years until he abruptly dumped me for a student of his, twenty years younger than me. I moved out—with the yarn. In my new apartment, with an ever-present glass of wine by my side—oh, I knitted the f*cking sweater.

I knew it would be an unwearable piece. My only plan was to incorporate his tattoos and the different necklines, the rest just came out as I angrily knitted away. After its completion, my best friend (and fellow knitter) and I hung it up. We found so much symbolism in many of the details that I had spontaneously incorporated during the process: it looks okay from the front, but is unraveling from the back. Is his heart in the right place? No, and it is obscured by his changing ideas of perfection. The right arm is much longer, his dominant hand with his obsessive-compulsive disorder and polite passive aggression that controlled our relationship.

I took it down about six months ago. The same friend found your museum online and has been urging me to contact you.

I don't need this piece anymore. I hope you like it.

Olinka Vištica and Dražen Grubišić

Amazing Grace conditioner

Unspecified time
London, United Kingdom

MR. AND MRS. W had an open marriage into which my friend Dave had been made welcome. After one of Mrs. W's stays at Dave's cabin in the woods overlooking the ocean, she left behind some travel-sized toiletries. On December 30, the Ws were killed in a car accident. Dave lost his best friend and the woman he loved, with no public forum to grieve in. In February, I went to Dave's cabin, and Dave gave me Mrs. W's toiletries. I'm giving you the message on the bottle. You are giving Dave his public forum.

FAIR ATTRACTION

Fair attraction

1985 to 2003 (18 years)
Amsterdam, the Netherlands

IN THE SUMMER of 1989 a painter friend, Frits van Leeuwen, wanted to buy a car. I lent him the money. He could not pay it back and in return made this painting of me, F and P, three Amsterdam men, who had been in a dashing and complicated love triangle for years. On a hot summer day we organized a big vernissage to reveal the painting. We had great times together and came up with idiotic plans such as a company with graves all over the world, so the urn with your ashes could continue to travel: Don't let death stop you from traveling. It was in the middle of the AIDS epidemic and death was always close.

I am the man in the middle. The man on my left quit the relationship and the man on my right died. Now, my own death is near. The painting may go to the Museum of Broken Relationships. Don't let death stop you from traveling.

Olinka Vištica and Dražen Grubišić

Burnt piece of wood

1993 to 2000
Watermael-Boitsfort, Belgium

WHEN SHE LEFT ME for another, I was heartbroken and sank deeper and deeper into a severe depression. Finally, when it had nearly killed me, my friends decided that something had to be done. We took everything that might trigger thoughts of her—our bed, mattress, pillows, books, any towels that might carry her scent, all her belongings, and even pictures of her—outside and set it all on fire. I had to throw up as the bonfire was lit.

It took me years to recover and gain some perspective. I calculated that the fire must have emitted about two tons of CO_2e, so I bought two CO_2e certificates to offset the emissions by sponsoring a youngster to plant trees around sports fields in Africa. It makes me happy to think that, in this way, all the bad things—even the fumes—have somehow been turned into something good, and that some youngsters are now sitting under a tree after playing sports, making friends, and falling in love.

Wedding dress

1995 to 2003
Zagreb, Croatia

CAN I GET IT back if I ever
decide to marry again?

Olinka Vištica and Dražen Grubišić

Acknowledgments

The idea for this book has been with us for a long time. Almost as long as the museum itself. Many people have contributed to the museum's expansion across the globe in all its diverse forms. We owe our inspiration to all of them.

A very personal thank-you goes to our dear friends Nevenka Koprivšek and Selene Foster, who sensed the museum's power at the time of its modest beginnings. They were behind the first key exhibitions outside of Croatia, in Ljubljana and San Francisco. We are also indebted to Annemarie de Wildt, our curator in Amsterdam, and Laura Kriefman, the "museum's ambassador" in the UK, whose work and enthusiasm were key to many beautiful, life-changing moments in this project.

We wish to thank John B. Quinn for his sensibility and his vision to take the concept of the Museum of Broken Relationships to Los Angeles, its first permanent outpost in the United States. Our gratitude also goes to Alexis Hyde, director of the Los Angeles museum, for facilitating the work on the contents of the book.

We thank Barbara Kulmer for her willingness to welcome our museum at one of the most beautiful spots in Zagreb, making it available for the world to see.

For their knowledge, dedication, and passion, we owe enormously to our editor Millicent Bennett and our lovely agents, Katherine Fausset, Mitchell S. Waters, and Timothy Knowlton of Curtis Brown. We have been so lucky to have worked with you.

Daniel Frankl, thank you for being a great matchmaker, a friend, and, last but not least, business adviser.

We owe so much to our fantastic team at the museum in Zagreb who invested their knowledge and effort in this truly global initiative. A special thank-you goes to our collection manager, Ivana Družetić, who worked on the selection of material for the book.

Nothing, of course, would have been possible without the love and support of our families. Our friends and associates Marija Curić and Dana Budisavljević stand next to them.

We couldn't be more grateful to all those anonymous memory keepers whose bygone loves fill these pages. This book belongs to them.

About the Authors

Olinka Vištica is an arts producer, born in Split, Croatia, and cofounder of the Museum of Broken Relationships. She holds master's degrees in English and French language and literature from the Faculty of Humanities at Zagreb University.

Dražen Grubišić is a versatile visual artist from Zagreb, Croatia. He holds a master's in painting from the Academy of Fine Arts in Zagreb and is a cofounder of the Museum of Broken Relationships.

Visit and contribute to the Museum of Broken Relationships at www.brokenships.com

Credit: Museum of Broken Relationships by Vladimira Špindler